Bridget Riley

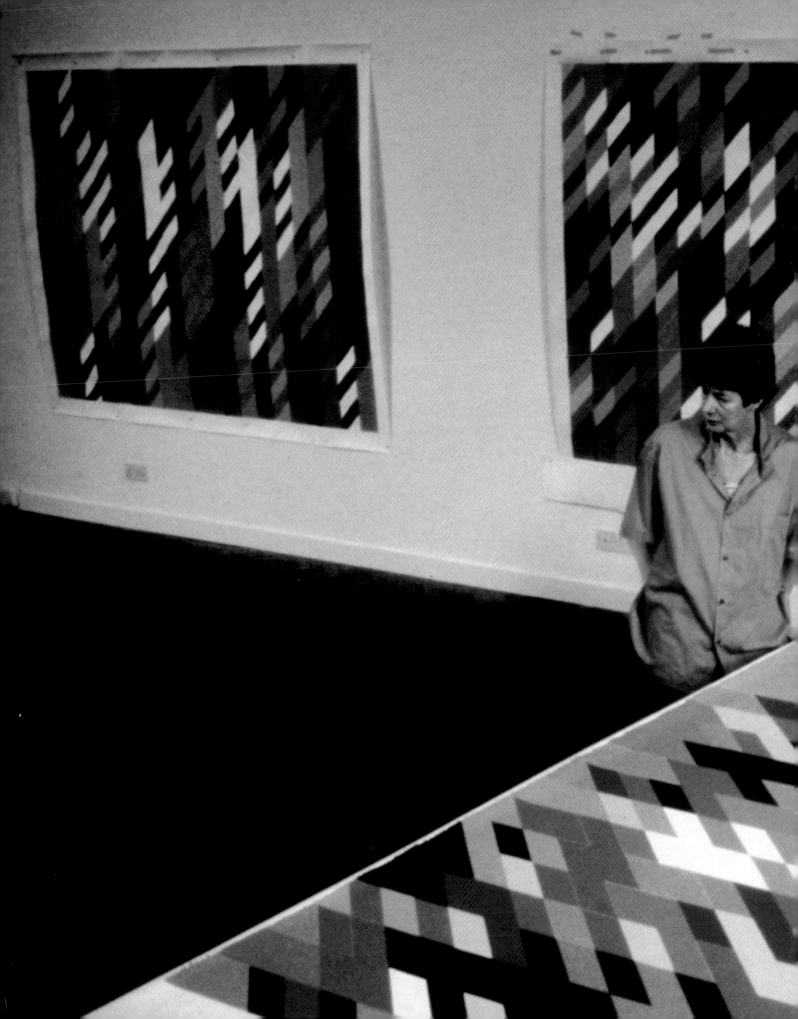

Colin Wiggins
Michael Bracewell
Marla Prather

Bridget Riley
Paintings and Related Work

National Gallery Company, London
Distributed by Yale University Press

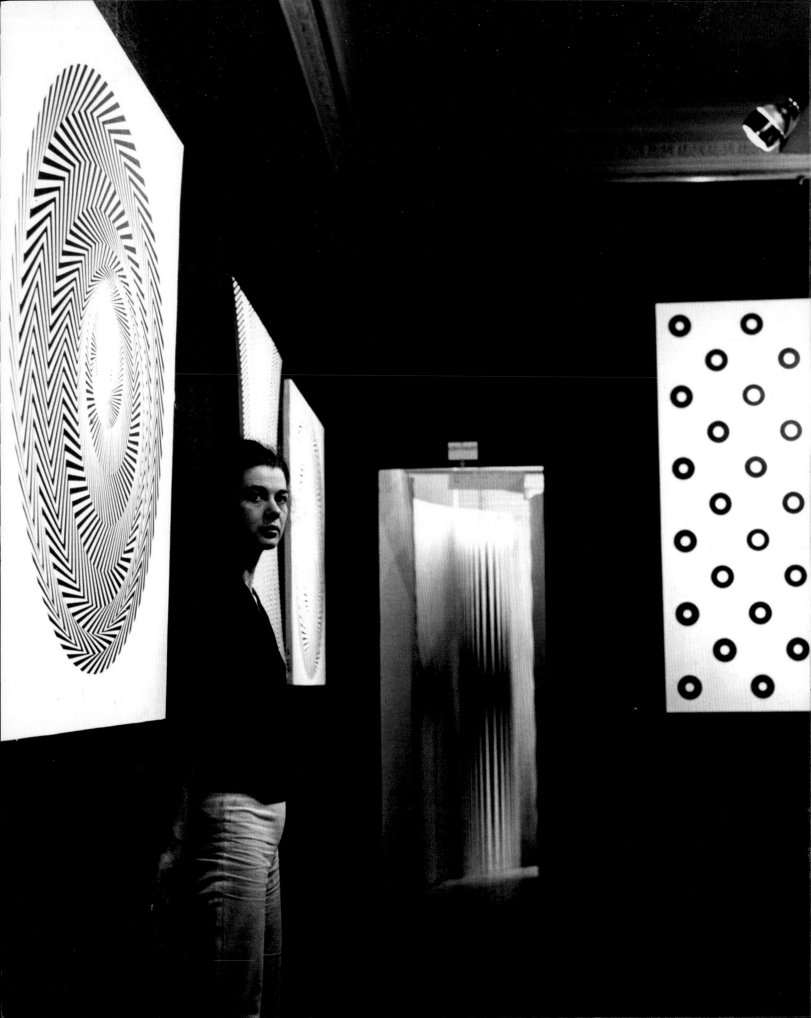

Contents

Sponsor's Preface

Bloomberg is delighted to continue its support of the National Gallery by sponsoring *Bridget Riley: Paintings and Related Work*. This exciting new partnership celebrates the work of one of the UK's most dynamic artists, and combines the commission of a major new wall drawing with a unique exploration of the way the National Gallery Collection has inspired Bridget Riley's painting over the years.

Bloomberg is a global financial communications company, one that is deeply committed to education and creativity, and to expanding access to art, science and the humanities across borders. For this reason, Bloomberg is particularly pleased that the exhibition is being shown in the Sunley Room, at the heart of the core collection, enabling new international audiences to experience Bridget Riley's work for free, many for the first time.

Sponsored by

Bloomberg

Director's Preface

When Bridget Riley became a household name in the early 1960s with her large black and white paintings, there was a legal battle (in which Joseph Penny, my father, was engaged as a barrister) to limit the commercial exploitation of her inventions. This was my first acquaintance with the serious claims of abstract painting. It was also an introduction to an important aesthetic question – is it an offence to convert part of an artistic composition into décor? The problem remains, since museums' marketing departments all over the world strive to obtain exactly the sort of coverage to which Bridget objected.

More than any art critic or art historian of her generation, Bridget Riley has risen to the task of defending high art, which means distinguishing it from the ornamental and from illustration. The strategy adopted in the past by leading intellectuals and theorists always involved dwelling on the subject matter of pictures, emphasising that the painter was akin to the epic poet, the writer of tragedy and comedy, or the natural historian. Bridget Riley has instead defended high art as great music.

For this reason, as well as for other many more specific services when she was a Trustee here, the National Gallery owes her a considerable debt. What she draws from the Old Masters here and elsewhere is a topic on which the essays that follow shed more light. But visitors who analyse what it is that captivates, or dazzles, or even unnerves them about her paintings will find that their appreciation of works in every part of the National Gallery has been sharpened. So what she has taken she has also returned.

It remains to thank Bloomberg, who have made this exhibition possible, and Colin Wiggins, who had the idea that we should put the exhibition on and helped to bring it about – displaying great tact and tenacity in the process.

Nicholas Penny
Director, The National Gallery, London

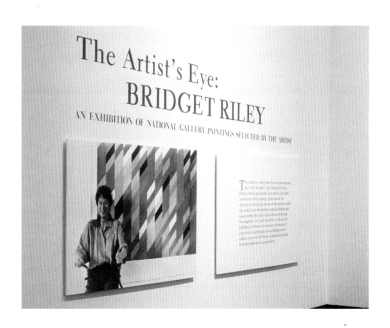

Figs 1 and 2
The Artist's Eye, Bridget Riley at the National Gallery, London, 1989

Colin Wiggins

Bridget Riley at the National Gallery: Making Connections

> I think Abstract art should try to be as resourceful and as expressive as the great figurative art of the past.
>
> Bridget Riley, 1995[1]

In 1961, at the age of thirty, Bridget Riley made her first abstract painting and her career took off rapidly. Almost fifty years later she is still an artist making radical works that are often described as 'cutting edge', who at the same time has a widespread popular following. Her celebrated black and white paintings have been seen as epitomising the spirit of the 1960s, even though her work was not without its challenges to the various establishments of the time. Her innovative approach to painting has continued to the present day, as is shown by the success of *Flashback*, the exhibition organised by the Arts Council Collection that is currently travelling to four UK venues and has met with a large and enthusiastic visitor response. Although in her eightieth year, Riley's appeal cuts across generations. Her work engages and stimulates not just those sections of the audience who grew up with her and have watched her career develop, but today's art students as well – a theme discussed by Michael Bracewell in his 'Introducing the Art of Bridget Riley: An Act of Translation' in this volume.

This exhibition is conceived to show how Riley's uncompromisingly contemporary abstract paintings, with special reference to her most recent works, have a strong and significant connection to the history of figurative painting. Riley has had a long association with the National Gallery: she made a copy of Jan van Eyck's *Portrait of a Man (Self Portrait?)* (plate 3 and fig. 3) as part of her successful submission to Goldsmiths' College in 1949. In 1981 she became a Trustee of the Gallery and in 1989 she was invited to select the 9th *Artist's Eye* exhibition (figs 1 and 2).

The *Artist's Eye* exhibitions were devised as a series in which artists were invited to make a selection of paintings from the Gallery's collection and display them alongside an example of their own work. Riley's choice was motivated by a desire to show the very particular way in which colour

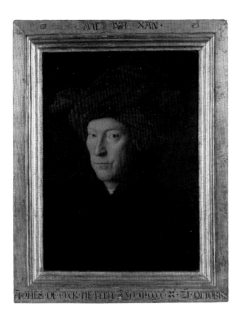

Fig. 3
Jan van Eyck (active 1422; died 1441)
Portrait of a Man (Self Portrait?), 1433
Oil on oak, 26 × 19 cm
The National Gallery, London (NG 222)

Fig. 4
Andrea Mantegna (about 1430/1–1506)
The Introduction of the Cult of Cybele at Rome, 1505–6 (detail)
Glue on linen, 73.7 × 268 cm
The National Gallery, London (NG 902)

was used by certain artists to build their paintings. She selected works by Titian, Veronese, El Greco, Poussin, Rubens and Cézanne, and in the accompanying catalogue and video she gave an account of her selection. The title of the exhibition was *The Colour Connection*. For this present exhibition Riley has chosen five paintings from the National Gallery. Two are from the Italian Renaissance collection: Andrea Mantegna's *Introduction of the Cult of Cybele at Rome* of 1505–6 (plate 2 and figs 4 and 5) and Raphael's *Saint Catherine of Alexandria* of about 1507 (plate 1 and fig. 8). These are joined by three small studies by Georges Seurat that were made between 1883 and 1884 (plates 19–21), in preparation for his monumental painting, *Bathers at Asnières* (fig. 10), which is also in the National Gallery.

Approaching masterpieces from the past through the eyes of a contemporary abstract painter can be a highly informative experience. All great paintings have an underlying abstraction to them, a point that Riley wanted to make clear in her *Artist's Eye* selection. Viewers, accordingly, can find themselves enjoying the works in a purely visual manner, irrespective of subject matter, and so discover new ways of approaching a picture. And by considering paintings from the past in this way, Riley's own abstraction, with its vivid sensations of rhythm and movement, can be appreciated as being built upon those same structural foundations of space, form and drawing as the works of her artistic precursors.

Such connections can be drawn in the selection of Mantegna's *Introduction of the Cult of Cybele at Rome,* a picture that refers to the moment when the Romans brought the cult of Cybele, an Eastern goddess, to their city – an event written about by Ovid, Livy and Appian. The picture was made to simulate a stone relief. The pictorial space, therefore, is shallow and Mantegna shows two processions of figures moving towards one another. Details in each of the two groups, such as a twisting head, a gesturing hand or a figure turned out towards us, provide variations within each movement. Mantegna's canvas (fig. 5) is wider than it is high, encouraging the spectator to scan the

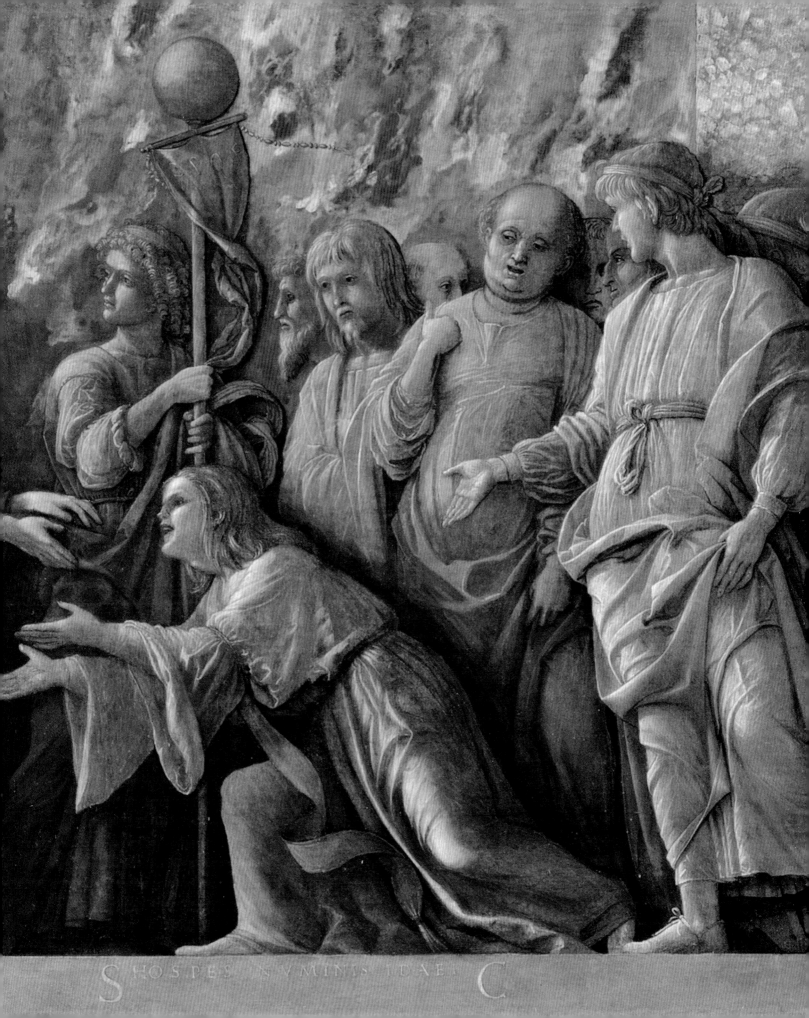

Fig. 5
Andrea Mantegna (about 1430/1–1506)
The Introduction of the Cult of Cybele at Rome, 1505–6
Glue on linen, 73.7 × 268 cm
The National Gallery, London (NG 902)

Fig. 6
Bridget Riley
Arcadia 1 (Wall Painting 1), 2007
Graphite and acrylic on wall, 266.5 × 498.5 cm
Private collection

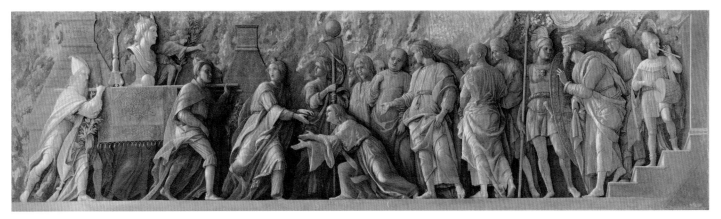

painting from left to right and back again. The composition is asymmetrical yet perfectly balanced. From the left, cloaked men deliver Cybele's sacred stone, while Romans line up on the right in various states of anticipation. As a result, the composition reflects a sense of a narration, of story-telling. Mantegna has looked carefully at ancient stone reliefs, which he saw on Roman sarcophagi, and these have coloured his sense of space, depth and movement.

With Raphael, it has become a convention to discuss his work in abstract terms: words such as 'purity', 'grace' and 'clarity' regularly occur in writings about the artist. In his painting of Saint Catherine (plate 1 and fig. 8) the saint is seen leaning on the wheel, her symbolic attribute. Riley was somewhat relieved to discover that, according to *The Golden Legend* (the popular medieval book of saints), the wheel was not the actual means of her death and that the threatened torture did not take place – in the end she was simply beheaded. It was said that her prayers were answered by the angels and that the wheel shattered at her touch.[2]

In Raphael's painting, Saint Catherine stands in a classic *contrapposto* pose, the upper part of her body twisting away from the lower part. This serpentine stance was believed to be an ideal form and can be found in works by many artists including those as diverse as El Greco and Michelangelo. It is notable that the curving line that Riley has introduced into her recent pictures, such as *Arcadia 1 (Wall Painting 1)*, 2007 (plate 8 and fig. 6), *Red with Red 1*, 2007 (plate 7 and fig. 7), and *Blue (La Réserve)*, 2010 (plate 10), all exhibited here, echoes the tension of Saint Catherine's figure.

There is a distinct connection between Raphael's exploration of this ideal form and Riley's studies of the circle, another ideal form, in her latest wall drawing, *Composition with Circles 7*, 2010 (see plate 9). Created specially for this National Gallery exhibition and painted directly onto the wall of the Sunley Room, it is the latest in a series of wall drawings that began with *Composition with Circles 1* (fig. 19), made at the Kunsthalle Bern in 1997. Following the same principles as the six previous wall drawings, *Composition with Circles 7* is made up of circles approximately one metre in diameter.

When they are seen together, their rhythms, intersections and abutments provide endless routes for the eye to travel across, over and around the composition, encouraging the viewer to find themselves 'lost in looking'.[3]

The movement from one colour to another in Raphael's *Saint Catherine of Alexandria* is also of interest. The vivid yellow lining of the saint's red cloak that encircles her shoulder and hip is supported by the blues of the sky and landscape, which reach an apogee in the blue-violet of her dress. Looking to Riley's *Arcadia 1 (Wall Painting 1)*, *Red with Red 1* and *Blue (La Réserve)*, it becomes apparent that her use of colours and how they respond to one another has a pedigree that reaches back to Raphael at his most classical. Artists have been aware in varying degrees of how the properties of a particular colour are affected according to the colour of its neighbour. Following in the footsteps of French nineteenth-century painters such as Seurat, who worked with and analysed the properties of colour, Riley's compositions such as *Saraband*, 1985 (plate 6), encourage and enhance our enjoyment of painted colour.

The representation of space and form is, of course, at the very heart of Italian Renaissance painting. Renaissance painters never imitated visual reality; instead, they provided an alternative reality based upon certain principles that we could justifiably call abstract. Although working nearly four hundred years later, Georges Seurat is similarly concerned with the construction of a reality based in perception and his careful synthesis of space and form shows him to be firmly located within the Western classical tradition that has its origin in the Renaissance.

Riley's connection to Seurat is more fully investigated here by Marla Prather in her text 'Let the eye be agile: The Past as Present in the Work of Bridget Riley'. The artist has selected for the current exhibition three small preliminary studies that reveal Seurat's preparatory work for *Bathers at Asnières*. As Seurat developed his painting, he made many such studies, which were an integral part of his working method. The same is true for Riley – preliminary studies are of great importance to her

and she is happy for them to be seen. 'I don't want there to be anything mysterious about the way that I work,' she says. 'I mean there is doubt and uncertainty, and the very act of enquiry means that things go wrong and have to be changed and revised. But to me this is part of the pleasure of working.'[4]

These are just three of the many surviving studies that Seurat used to gather the visual information with which he built his final composition. One study selected by Riley, *A River Bank (The Seine at Asnières)*, about 1883 (plate 20), establishes the location, where he pins down the diagonal division between water and river bank. Seurat makes special use of the striped tidal-measuring post, which helps to carefully balance the compositional components of horizontal, diagonal and vertical. In *Study for 'Bathers at Asnières'*, 1883–4 (plate 19), he makes notations of some of the figures that will eventually relate to this location. Lastly, in *The Rainbow: Study for 'Bathers at Asnières'*, 1883 (plate 21), he begins to integrate the figures into the space. Riley understands this little study as being one of several of this nature, in which he repeatedly painted the scene to keep the colour sensation fresh in his mind. The studies show Seurat's focus on the lines of the composition, the connection between figure and field, and the relationship between colours. Seen in conjunction with her recent paintings, Riley's interest in Seurat, which she describes as a 'shared preoccupation with perception and a love of contrast in painting', continues today.[5] Seurat's studies were all made between 1883 and 1884, a generation before pure abstraction entered Western painting and yet, with hindsight, their abstract properties, and consequent connection to Riley's work, become clear.

Riley's approach to her own paintings is similarly methodical. 'When I start I don't have an aim or an image in mind for how the painting is going to look,' she explained to the art historian Lynne Cooke in 2005. 'When I started to do studies at the beginning of the 1960s, few other artists made preparatory works. Most people felt that they were not spontaneous or sufficiently informal: it was thought that any form of preparedness was somehow a bit inartistic. But I felt that – I didn't just feel,

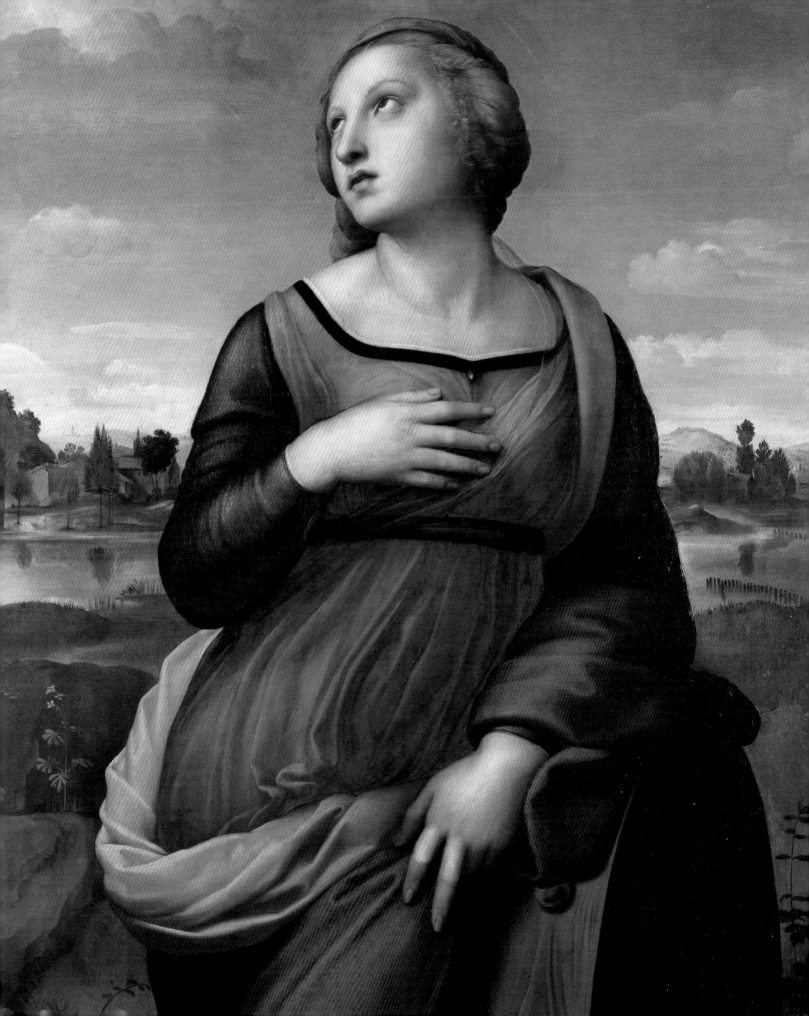

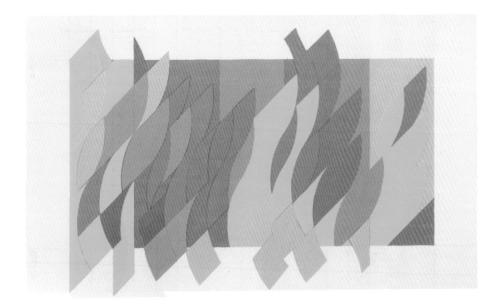

Fig. 9
Bridget Riley
**Collage Study, Bassacs.
Further revision of June 11,**
2005
Gouache collage, 47.6 × 80 cm
Private collection

I *knew* – from all the evidence of what was to be seen in museums that drawing and preparatory work had always played a large part in an artist's practice.'[6] Riley has used her own form of collage (fig. 9) as an important part of her preparatory work since the early 1980s: first for her striped paintings such as *Saraband* and then through the paintings such as *Red with Red 1*, *Blue (La Réserve)* and *Arcadia 1 (Wall Painting 1)*. However, she does not use collage for any of her wall drawings. Earlier this year while putting together a talk for the British Museum about Renaissance drawings, Riley was shown a study of about 1447–9 by Benozzo Gozzoli entitled *A Nude Man with a Horse*. Gozzoli had used a strong blue ground as integral to the formation of the figures. Riley recognised that the white wall of *Arcadia 1 (Wall Painting 1)* made a similar use of the ground. The French refer to this practice as '*la réserve*' and it plays an important role in the development of her wall paintings.

In 1890, not long after Seurat's studies were made, Maurice Denis made his famous and often quoted statement that has been claimed as an anticipation of twentieth-century abstraction: 'It should be remembered that a picture – before being a war-horse, a nude, or an anecdote of some sort – is essentially a flat surface covered with colours assembled in a certain order.'[7] This would seem especially pertinent to the work of Bridget Riley. It is her stated belief that 'abstraction is fundamental to painting in general'. 'Painting has been an abstract art long before Abstract art became a style and a theory,' she says.[8] Indeed, Riley's recent paintings can be seen as an abstract distillation of those essential features of Western figurative painting that make it what it is. Her work strips away elements of representation and narrative, revealing those underpinning elements of colour, space, rhythm and movement to be the building blocks not just of her work, but of the whole tradition of Western painting.

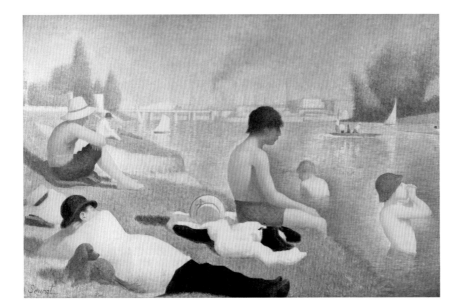

Fig. 10
Georges Seurat (1859–1891)
Bathers at Asnières, 1884
Oil on canvas, 201 × 300 cm
The National Gallery, London
(NG 3908)

NOTES

1 Bridget Riley, 'Something to Look At, in conversation with Alex Farquharson' (1995) in *The Eye's Mind: Bridget Riley. Collected Writings 1965–2009*, ed. Robert Kudielka, London 2009 (revised edn), p. 156.

2 Jacobus de Voragine, *The Golden Legend*, trans. Christopher Stace, London 1998.

3 Adrian Searle, 'Lost in Looking', *Guardian*, 7 September 2006.

4 *The Eye's Mind*, 2009, p. 177.

5 *The Eye's Mind*, 2009, p. 61.

6 *The Eye's Mind*, 2009, p. 309.

7 Maurice Denis, 'Définition du Néo-traditionalisme', *Art et Critique*, 30 August 1890.

8 *The Eye's Mind*, 2009, p. 174.

Michael Bracewell

Introducing the Art of Bridget Riley:
An Act of Translation

Attending Bridget Riley's exhibition at the Hayward Gallery, London, in 1971, it was revealing to witness the dramatically involving effect that her work had on its viewers. These were paintings that rewarded the gaze directly, coming to vibrant, motion-filled life, at once immediate, visceral and deeply meditational. 'No painter, dead or alive,' began Robert Melville's review for the *New Statesman*, 'has ever made us more aware of our eyes than Bridget Riley.'

The truth of Melville's pronouncement would be self-evident to anyone who has stood in front of a painting by Riley – from any period in her career – and accepted its invitation to look and to see. Each painting comprises its own closed circuitry of movement and form, refining our perception to pure sensation, beyond intellect.

As the viewer begins to look, so they are swiftly drawn into a series of interrelated optical negotiations and visual surprises. There is no single place on the work where the eye might attempt to find rest and to focus – no apparent 'magnetic north' by which it might take its bearings. Rather, as the eye explores, so the painting reveals its own individual life, at its own pace, and on its own terms. Movement, agitation, interruptions, reversals, disappearances and new 'actions' all occur within the work, often faster than the eye can keep up with them, and drawing the viewer into what might be called the consciousness of the painting, with all of the engulfing power of a strong current. And thus, at the Hayward Gallery and at all of Riley's exhibitions, each painting appears to attract its own audience of viewers – each one of whom, through the act of looking and seeing, also become participants in its visual and emotional world.

The aesthetic and emotional power of Riley's art is the product of continuous artistic enquiry on the part of the artist, the findings of which liberate the wholly autonomous sense of movement and independent 'life' within each work. This process of enquiry derives from both the heightened nature of Riley's sensory engagement with the world around her, and from a deeply felt engagement with the work of earlier artists.

Fig. 11 Bridget Riley in her Warwick Road studio, 1960s

19

The nature of this dialogue with the past, with specific reference to the sense of 'life' within a painting, was well summarised by the artist in a conversation with Michael Craig-Martin:

It's amazing that some paintings from the past are so extraordinarily modern while others, even some contemporary paintings, appear quite stale. It seems that painting presents certain problems with which artists inevitably have to come to terms no matter what period they are living in ... To treat them [paintings from the past] as historical documents or evidence of past concepts is wrong – they are particular solutions to continuing artistic problems, and it's that which makes them real, or as you say, 'living'.[1]

What might be the nature of this 'aliveness' in the art of Bridget Riley? Clearly, as can be seen from the connections made in this current exhibition, it is an analysis of sentience that derives on one level from Riley's career-long absorption in the problems posed by the history of art, and by painting in particular. In her pioneering development of abstract painting, Riley has accepted the challenges and questions posed by Modernism – Malevich, Stravinsky and Proust are all key figures in her dialogues and writings – and re-phrased through the artistic innovations of the early and middle years of the last century. In her lecture 'Painting Now', delivered at the Slade School of Art, London, in the autumn of 1996, for example, Riley looked to Samuel Beckett to define the task of the artist:

When Samuel Beckett was a young man in the early 1930s, and trying to find a basis from which he could develop, he wrote an essay in which he examined Proust's views on creative work, and he quotes Proust's artistic credo as declared in *Time Regained* – 'the task and duty of a writer (not an artist, a writer) are those of a translator'. This could also be said of a composer, a painter or anyone practising an artistic *métier*. An artist is someone with a text that he or she wants to decipher.[2]

As interpreted by Riley by way of Beckett, the artist's 'text' 'cannot be created or invented but only discovered within the artist by him or herself, and that it is, as it were, almost a law of his own nature. It is his most precious possession, and, as Proust explains, the source of his innermost happiness.'[3] For Riley, in order for the artist to achieve real progress – and more, emotional acuity – within their work, they must ceaselessly study and test their own progress, learning particularly the necessity for sacrifice within the creative process. In this, Riley has identified a lineage of enquiry; and the development of her own work – her translation of her own text – stems in part from her continuing participation within this art historical relay of self-questioning.

Black to White Discs (1962, plate 5) is an early example of Riley's translation of idea and enquiry into autonomous sensation and emotion. A square comprised of small, uniformly sized and evenly spaced circular discs, appears to be balanced on one of its corners, thus assuming a diamond-like shape. The discs comprising the left hand side of the balanced square appear to emerge from a mist – the disc furthest to the left seeming the palest (nearest to white) and those towards the right acquiring a gradually deepening shade of grey, line by line, until we reach the axis of the vertical line

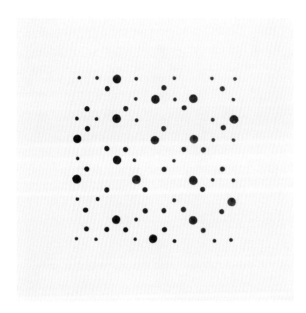

Fig. 12
Bridget Riley
Study for White Discs, 1964
Gouache on paper, 27.3 × 28 cm
Private collection

of near black discs which runs down the square's centre. But the true black runs just to its right.

The gradual 'fade' from black through shades of grey appears to have the twofold effect of softening and 'slowing down' the energy contained within the finished painting's scale and visual impact. The square acquires the sensations of new properties: it becomes both weighted and weightless; it seems to drift, or rotate through space. Above all, it is possessed of a sense of deceleration.

In a conversation with Maurice de Sausmarez, conducted in 1967, Riley said of *Black to White Discs*: '… when I had *Black to White Discs* on a small scale it was a slow painting, and when it became larger it became slower still. When its character was revealed in this slowness I realised that by increasing the scale a more positive statement of slowness would be made.'[4]

A further refinement of the relationship between movement and scale discovered within *Black to White Discs* can be seen in *Study for White Discs* (fig. 12), made in 1964. This smaller work comprises black discs of varying size on a white background; as the viewer shifts their gaze these discs leave the fleeting optical effect of a white after-image, hovering just above the surface of the work. *Study for White Discs* is a slightly 'faster' work than its predecessor, yet still it remains tranquil; in its abbreviated diagonal groupings of varying sized discs, it seems also to introduce the impression of twisting DNA-like columns of downward movement, caught in a dead slow horizontal drift. The somewhat elegiac feel of *Black to White Discs* seems therefore replaced by both a lightening and tightening of mood.

In one sense, *Study for White Discs* depicts another square, and yet the demarcation of the sides of this square – porous to the white of the background – propose its solidity and aesthetic purpose to be a consequence of its very effervescence. In this, Riley's art achieves a further liberation: to create deft reversals of pictorial effect – solidity becomes space; black becomes white; that which is still begins to move.

For the newcomer to her work, the art of Bridget Riley can appear simultaneously inviting – spectacular, even – and possessed of a sensory power that can be epic to the point of overwhelming. There is no lack of grandeur in her art – as her recent *Composition with Circles* wall drawings (plate 9 and fig. 19) prove with such force and grace; but likewise, as can also be seen in *Composition with Circles*, the emotional power of each work, and its internal animation, derives from a translation of perception into form that is so refined and meticulous as to resemble a formula of aesthetic calculus, in which the values of simplicity and discipline are attained from the algebraic resolution of sense and emotion.

With this in mind, one can see how the sheer drama of Riley's earliest 'black and white' (or 'Op') paintings of the early 1960s are gradually advanced in their complexity ('paced' is Riley's own term for her cumulative enquiry into the capacities of a form) until they reach what might be called the critical mass of their aesthetic. Then, greys were introduced by the artist and paced, to be followed by colour; linear and geometric forms could subsequently give way to twists and undulations; later still, diagonals and 'zigs' appeared; and so on to curves and curvilinear forms. And the journey is far from over.

In an illuminating statement, Riley has observed of her early black and white paintings how 'People at the time thought, and some people still seem to think, that they were paintings having to do with optical experiment … really they were an attempt to say something about stabilities and instabilities, certainties and uncertainties.'[5] The development of this intention can be seen in Riley's earliest enquiries into colour, of which *Arrest 3* (1965, plate 4) is an example. Here, Riley appears to first acknowledge, and then embrace, a fresh spirit of harmony and centrality. Her later colour paintings – such as the warm and vivacious *Saraband* (1985, plate 6) – are by then possessed of exuberant assurance, as though they can barely contain their lifted spirits. (One might compare them, in literary terms, to Walt Whitman's 'Song of Myself' or André Gide's prose hymn to nature, *Fruits of the Earth*.)

Arrest 3, by contrast, is a cooler and more measured work. Its power lies in its fluidity, rhythm and sudden pause, as conveyed by the undulation of its horizontal, ribbon-like lines. The dialogue between 'certainty' and 'uncertainty' remains, but now it seems that there are shades of 'assurance' in between. In the uppermost third of the painting, the curved bands change colour from near black, through warm and cold greys. They have a gentle swell, the motion of which appears reanimated by the reprise of black, halfway down the painting, which is followed by a repetition of the upper colour sequence, but comprised of narrower ribbons of colour. The swell intensifies. Marking the start of the painting's lower third, a fine undulation of light grey is followed by an abrupt 'stop' – and a change in the direction of the flow (from right to left) and by a gradual lightening of colour to mist-like whiteness – somewhat reminiscent of the softness and gentle movement conveyed in the left hand side of *Black to White Discs*.

In *Arrest 3*, the gradual deepening of colour from near translucent whiteness, to a shining hue (a hue which seems to have the texture of satin) and then on to near black, appears more temperate – warmed to sea temperature, so to speak, from the chill of sepulchre or deep space. When, in the lower section of the painting, the curved bands change direction and the visual authority of black falls away, there is a feeling that the dominance of this dark shade must now accept its place within

the parity and process declared by the work as a whole. The era of confrontation is over. In the lower third of the picture the paler colours appear to take command: strength begets strength and confidence begets confidence. That which was 'stopped' seems to resume, as though in a minor key, serene.

The painstaking precision with which Riley works towards new statements within her finished paintings can be seen from the meticulous studies by which they are preceded. Often made on finely ruled graph paper, these studies are both the 'working out' of Riley's paintings and, in an important sense, the declaration and template of the 'narrow frame that I have assigned myself for each one of my undertakings' – as the artist has quoted from Stravinsky's *Poetics of Music*, to describe a 'guiding principle' of her working methods. The quotation from Stravinsky concludes: 'I shall go even further: my freedom will be so much the greater and more meaningful, the more narrowly I limit my field of action and the more I surround myself with obstacles. Whatever diminishes constraint diminishes strength.'[6]

With this in mind, *Arrest 3* and its study possess a rhythm and musicality that Riley has also identified in the Mantegna frieze in the National Gallery, *The Introduction of the Cult of Cybele at Rome* (plate 2). It is as though Mantegna, too, had understood in advance of Stravinsky the artistic strengths to be gained from constraint. Speaking about that work with Neil MacGregor she observed:

I was amazed to see that Mantegna holds together the narrow horizontal format of his frieze in one long, all-embracing rhythm. The verve with which the first figure steps forward is stopped, cut short by the straight line of the statue, as though by an enormous comma; then this movement, introduced by the first figure, is picked up by the next two, turned around in the supplicating figure and continues in reverse until the very last figure where it changes back to echo the first.[7]

Riley's description of the frieze is thus particularly insightful, revealing the precision with which she deconstructs works by earlier artists in terms of their composition, and, more specifically, how that composition is in its turn descriptive of the artist's mind at work – the deduction and decision-making which comprise the Beckettian 'act of translation'.

Towards the end of the 1990s, Riley commenced making new paintings and gouaches that explored the relationships between diagonals, verticals and curves. In fresh, vivid shades (orange, violet, blue, cerise, yellow, for example) solidity and fluidity coexist within these bold and muscular paintings, seeming to push to its limit the confluence of directions of visual momentum. Vertical sections appear to underlay diagonals, in turn traversed by sinuous fragments of curve and arc. One might think of a plant on a riverbed, its frond-like leaves caught in the current, drifting yet tethered, fixed yet always in motion.

Red with Red 1 (2007, plate 7) comprises areas of dark blue, magenta red and orange red. The painting is traversed by nine diagonal sections, with a vertical plane running down its centre. The straight edges that form the boundaries of these sections are under constant interruption and intervention by curved and curvilinear areas of colour.

Fig. 13
Paul Cézanne (1839–1906)
House with Red Roof, 1887–90
Oil on canvas, 73 × 92 cm
Private collection, USA

To decipher what system of repetitions and overlays might govern the finished painting appears impossible – and, in one sense, a nugatory exercise. Rather, the viewer becomes aware that within this complex matching of curved and straight-edged areas of colour, of etiolated tears and blade-like curves, there is both horizontal and vertical movement, marked by fragments of what appears to be twisting or rotating motion. Everything moves to the right, as though in procession, curved edges leading. Crucially, all movement within the painting feels to move towards a sensory-visual event: a 'breaking through' into opened new territories.

In her essay 'Cézanne in Provence' (2006), Bridget Riley sheds further light on both her profound relationship with the work of earlier artists (Cézanne himself being one of her greatest ancestors within the history of art, along with Seurat, Monet and Mondrian) and, tangentially, on the Proustian impulse of recognising those 'triggering' sensory events that serve to open memory and recreate perception. Describing Cézanne's *House with Red Roof* (1887–90, private collection; fig. 13), Riley identifies the use of a 'tilting' effect in the work that she declares as 'essential to the dynamics of the painting'. She observes, 'This is our first encounter with *"ma petite sensation"*'[8] – referring to Cézanne's term for those fugitive moments of perception which seemed suddenly to reveal the world anew to him. (Proust's '*mot juste*' and Virginia Woolf's 'moments of being' have a similar, although not identical function.) Riley's career-long study of Cézanne, and her direct engagement with the relationship between looking, seeing and painting which he pioneered, has been a vital informant of her work. Cézanne's *Still Life with Plaster Cast* (about 1894, Courtauld Gallery, London) is a work to which she has made reference, noting the occurrence of the '*petite sensation*' in a further instance of 'tilting' within the painting – in this case the sudden, logic-defying but sight-pleasing upward turn of the plane behind the plaster cast of the putto.

We might see a connection between Riley's identification with Cézanne, and her extensive reading of Proust. Both Proust and Cézanne, like Riley herself, are foremost pioneers of perception:

in literary and visual terms respectively, they seek to understand first how we see the world around us, and then how that experience of witness can be 'translated' into art. As a young man, Proust, like Riley, undertook copying from earlier masters – seeking to both master their iconic styles and, by doing so, free himself from devotional imitation of their achievements. Only in this manner could he hope to discover his own style, and, in Riley's astute phrase, advance the solution to 'continuing artistic problems'.

Proust's (not uncritical) veneration of the writings and art criticism of John Ruskin led him to write an essay which both engaged with Ruskin's own literary style (his very temper, one could say) and allowed him to make a response. One passage touches closely on an artistic phenomenon very similar to Cézanne's '*petite sensation*', and seems also to rehearse the case for pure abstraction in art. Proust seems to step forward from behind the technical brilliance of his pastiche to address Ruskin directly: 'No, I shall not find a picture more beautiful because the artist has painted a hawthorn in the foreground, although I know of nothing more beautiful than the hawthorn, because I want to remain sincere and I know that a picture's beauty does not depend on the things portrayed in it.'[9]

Proust's phrasing is subtle, containing a question within its statement: upon what does a picture's beauty depend, if not on the things portrayed in it? Riley's analysis of Cézanne's *House with Red Roof* seems to answer this question: the beauty depends on the working out of the problems each painting inherits or brings to light. Time and again, in her dialogues and essays, Riley returns not to discussions of subject matter, inspiration, theory or even philosophy; but to the precise sensory and technical means by which a painting may be freed from the hand of the artist and achieve its own life – born clean of its maker's fingerprints, or the imprint of their personality.

Equally clear – as the acuity of her deconstruction of the Mantegna frieze exemplifies – are the lessons and insights that Riley has gained looking at the work of other artists, always in terms of problems posed and problems solved. This, on the part of Riley, is an almost supernatural act of art critical empathy: in her close study of paintings by earlier artists, Riley enables herself to see as those artists saw – pursuing on their canvases the train of thought, insight and intuition which connected their eyes to their hand. In turn, through her finished paintings, Riley passes on this empathetic understanding of perception. She reveals to the viewer, as translated into living, freed and autonomous works of art, her own moments of being, and her own incidents of '*petite sensation*' – as surely as those by Cézanne or Mantegna or Raphael (see pages 12–13) have revealed theirs to her.

NOTES
1 *Bridget Riley: Dialogues on Art*, ed. Robert Kudielka, London 1995, p. 51.
2 Bridget Riley, 'Painting Now', 23rd William Townsend Memorial Lecture, Slade School of Fine Art, London, 26 November 1996.
3 ibid.
4 *The Eye's Mind: Bridget Riley. Collected Writings 1965–2009*, ed. Robert Kudielka, London 1999 (revised edn 2009), p. 78.
5 ibid., p. 147.
6 *Dialogues on Art*, 1995, pp. 34–7.
7 ibid., p. 23.
8 Bridget Riley, 'Cézanne in Provence' (2006) in *The Eye's Mind*, 1999, p. 250.
9 Marcel Proust, 'John Ruskin' in *Against Sainte-Beuve and Other Essays*, London 1988, p. 190.

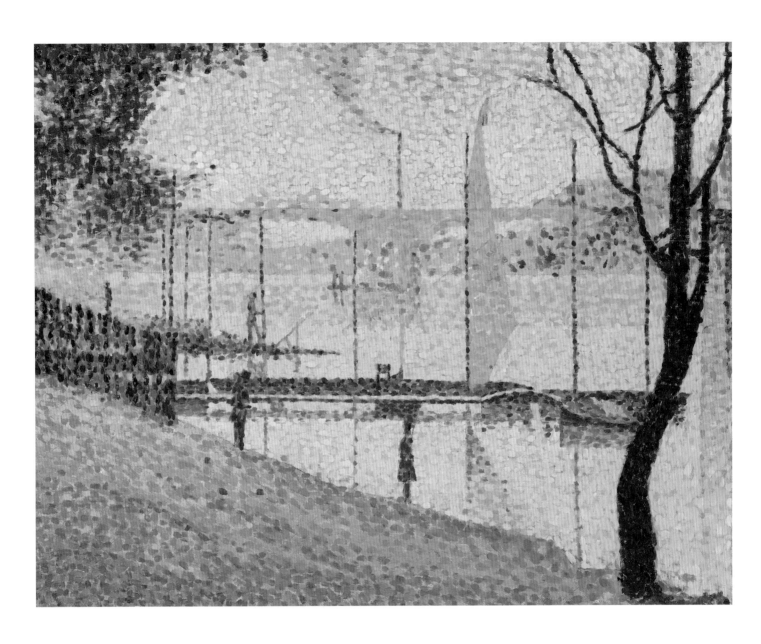

Fig. 14
Bridget Riley
Copy after The Bridge at Courbevoie by Georges Seurat, 1959
Oil on canvas, 71.1 × 91.4 cm
Private collection, London

Marla Prather

'Let the eye be agile':
The Past as Present in the Work of Bridget Riley

> Artists cannot help, it seems, but project some of their own preoccupations
> onto the art of the past, and this is more or less true of everybody, even
> art historians. However, as a painter you see reflections of common
> practical problems in the art of the past, and although the solutions
> obviously cannot be the same, it is still reassuring to see that one's own
> problems are not simply delusional but real, by witness of the fact that
> other painters have encountered them.
>
> Bridget Riley[1]

In 1947, as Bridget Riley sought admission to London's Goldsmiths' College in the University of
London, where entry was highly competitive in the years after the war, someone suggested that she
copy a painting for her portfolio. She chose as her model Jan van Eyck's *Portrait of a Man (Self
Portrait?)*, 1433 (fig. 3), in the National Gallery's collection. Although access to the original was
readily available, she painted the work (plate 3) from a postcard. It was not the elaborately complex
folds of the sitter's extraordinary red head-dress that drew Riley to van Eyck's portrait, but rather the
regular features of his 'beautifully constructed head', with its very distinct planes.[2] In retrospect it
may surprise us that an artist who would become one of the most committed abstractionists of the
last fifty years not only undertook an ancient academic practice, that of copying, but also turned to
a masterpiece of meticulous realism. And her choice – a rare work by one of the greatest artists of
the first half of the fifteenth century and among the most celebrated paintings in a British public
collection – was hardly a timid one for a young student. It suggests even a concerted personal
declaration, to select what may be van Eyck's portrait of himself. But rather than an act of immodesty,
it was Riley's first lesson in what she has called 'the old way of learning'. Copying is the greatest
possible tribute to the continuing relevance of the past, particularly for an artist who believes that

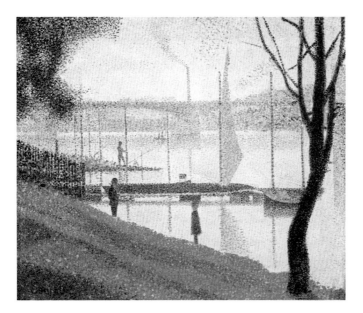

Fig. 15
Georges Seurat (1859–1891)
Bridge at Courbevoie, 1886–7
Oil on canvas, 46.4 × 55.3 cm
The Samuel Courtauld Trust, Courtauld
Institute of Art Gallery, London
(P.1948.SC.394)

painting's central issues do not fundamentally change from century to century, that an artist can advance in her own work by embracing the past, and that figurative art can offer solutions to the abstract artist through the common ground of a shared medium. 'Doing the same', she claims, 'is a way of getting closer than you ever can by simply observing.'[3] Although the full implications of copying came later, Riley's choice of the van Eyck in 1947 is an early manifestation of her conviction that the best artists in history (she dislikes the term 'Old Masters') offer the clearest models to students of painting: 'Look at the great painters; don't be frightened of them, they've seen more clearly, experienced more deeply and are more explicit. Weaker artists are confused. Read the best, look at the best. Don't rely on your contemporaries, look at the past.'[4]

Once she entered Goldsmiths', Riley devoted herself to the study of life drawing, a declining practice in art schools by that time, and she still remembers with great affection her teacher Sam Rabin and consistently credits the importance to her work of this early academic training. She does not personally execute her final paintings but she precedes them with studies, precisely rendered, notated drawings, gouache collages, and cartoons (see plates 11–18). Rabin taught by example, and Riley learned in part by observing his actions as he drew. Like so much of her work, drawing is a form of enquiry, a means of gathering information through close examination of the visible world. In her essay, 'From Life', for a recent exhibition of some of these early figure studies at the National Portrait Gallery, London, Riley wrote, 'Drawing is an exercise in looking: one finds out what can be seen and at the same time one finds oneself having to organise the visual and emotional information extracted.'[5] Rabin also encouraged Riley to study drawings and prints in the collection of the British Museum – by Raphael, Rembrandt, Ingres – and she valued the intimate experience of examining works of superlative quality at close range. In May 2010 she delivered a lecture at the British Museum that coincided with an exhibition of Italian Renaissance drawings from its own collection and that of the Uffizi Gallery, Florence. Riley framed her discussion of these works in a manner that

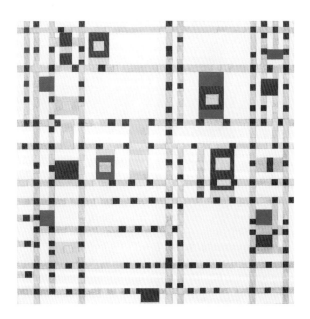

placed them within the context of her own artistic concerns and illustrated the broad historic sweep of her sensibility. She began on a personal note with her own early figure drawings, followed by remarks about the Italian master drawings. She moved on to the drawings of three modern artists whose work she values so highly: Seurat, Van Gogh and Cézanne. After a discussion of her early abstract work, she ended her commentary with Piet Mondrian's *Broadway Boogie Woogie* (1942–3, Museum of Modern Art, New York; fig. 16), another painting she has long admired, written about and tried to copy. She abandoned the effort once it became apparent that she could not unravel the artist's process and therefore could not profit from copying his work. Appropriately, her talk was titled, 'Learning to Look'.[6]

Riley has explained that copying the van Eyck was an isolated experience, not one she could build upon.[7] But it was a formative instance of Riley's work being nurtured by the extraordinary art at hand in her native London. Later, through her extensive travels, she became a dedicated student of European painting in museums throughout the world and has likened visiting museums to 'a journey in time, through which one discovers partners in imagination and whole areas of creative adventure'.[8] By 1959, her student training more or less complete, she turned to another artist for guidance in a very deliberate way, when searching for a path into colour after a protracted period of life drawing and various other pursuits, including teaching art to children and working in an advertising agency. It was *Bathers at Asnières* (1884, fig. 10), Seurat's early masterpiece in the National Gallery, that first provided the initial revelatory example, and Riley has included in the exhibition three of his luminous *plein-air* studies for the painting (plates 19–21). But for copying she turned to the Courtauld's *Bridge at Courbevoie*, 1886–7, a small work in Seurat's fully developed pointillist manner (figs 14 and 15). The exercise yielded a critical point of contact between a young painter at the brink of a mature career and a master of the past, one who was trained in the French classical tradition, who drew from the live model and the antique, and made many drawings after

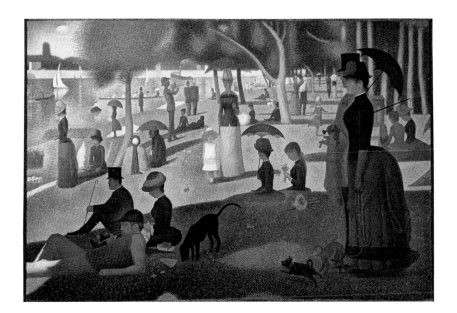

Fig. 17
Georges Seurat (1859–1891)
**Sunday Afternoon on the Island of
La Grande Jatte**, 1884–6
Oil on canvas, 207.5 × 308 cm
The Art Institute of Chicago, Illinois.
Helen Birch Bartlett Memorial Collection
(1926.224)

great artists, from Raphael to Poussin to Ingres. As with the van Eyck, Riley based her Seurat copy on
a reproduction (facing the original was 'too intimidating'), though her version is roughly thirty per
cent larger than Seurat's small canvas. Riley had tested other approaches as she searched for her
own pictorial language:

> I looked at paintings, read about artists I admired, and tried many avenues, in particular those
> opened up by Munch, Matisse, and Bonnard – painters whose handling of colour was a major
> factor in their art and all of whom had started out from an academic background. I attempted to
> copy a Bonnard but abandoned it because it seemed impossible to follow his train of thought.
> I realised his work, beautiful as it is, relied on an impromptu, almost *ad hoc* continuum of
> intuitive responses that left one at a loss as to the order in which they had occurred.[9]

Seurat's painting, on the other hand, provided an exacting model, a wholly legible surface that Riley
could follow, feeling her way through his process, discovering his train of thought. She realised, for
example, that the artist prepared his canvas with a traditional ground of diluted yellow ochre and
that beneath his tiny dots lay a network of larger hatch marks used to initiate his forms. Though
faithful to his composition, Riley took liberties with Seurat's palette and touch, using a larger brush
with the aim to analyse rather than mimic his optical mixtures of colour: 'I was trying to find out
where he put what colour and why.'[10] Critically important for her later work, in Seurat's pointillist
technique Riley could explore both the appeal and the limits of an objective, methodical approach,
where colour theory meets the workings of the human eye and heart. Throughout her career, Riley
has charted her own course, usually operating outside prevailing artistic trends. As Robert Kudielka,
Riley's longtime friend and fellow traveller, as well as the leading scholar of her work, has noted,
Seurat was 'not a hero of the 1950s', and, apart from John Rewald's seminal contribution, there was

at the time a dearth of current literature on his work.[11] But just before Riley's crucial encounter with Seurat, Meyer Schapiro had taken issue with the notion that the Frenchman's '*méthode*' derived from a purely programmatic or scientific approach. 'Seurat's hand has what all virtuosity claims: certitude, rightness with least effort … I cannot believe that an observer who finds Seurat's touch mechanical has looked closely at the pictures.'[12] Similar arguments were once waged against Riley's early black and white abstractions, though the artist has long made it clear that she has never relied on scientific theory. As Riley saw it, '[Seurat] wanted certainty, and what is so amazing is that he actually achieved it, though not in a scientific sense but in a painterly one … In the end the evidence was visual rather than cognitive.'[13]

The full impact of Riley's student apprenticeship to Seurat evolved over time. Her early enquiries clearly helped set her on the path to abstraction, but she has continued to draw sustenance from Seurat's work at various points throughout her career. Her tribute to him has extended well beyond her explorations in the studio, for she has spoken and written at length about the artist on several occasions. She reviewed the 1991 centennial retrospective at the Grand Palais in Paris and subsequently included remarks on Seurat in her 1993 lecture, 'Colour for the Painter'.[14] Most recently, she contributed an aptly titled essay, 'Seurat as Mentor', to the retrospective of his drawings held at the Museum of Modern Art in 2007. Her personal recollections of copying Seurat are thoughtfully integrated with her close reading of his tonal drawings, one of which she had also copied in 1984, and with insights into the evolution of her own work. On this occasion she quoted for the second time the marvellous exclamation of Seurat's great champion, Félix Fénéon, as he described *La Grande Jatte* (1884–6, Art Institute of Chicago; fig. 17) at the last Impressionist exhibition in 1886: '… here in truth the accidents of the brush are futile, trickery is impossible; there is no place for bits of bravura, – let the hand be numb, but let the eye be agile, perspicacious, cunning.'[15]

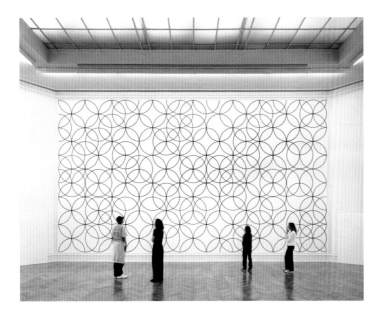

Building on her Seurat tutorial, Riley originated her own compositions in a pointillist technique, culminating in *Pink Landscape*, 1960 (fig. 18). Though executed in her London studio, the work was based on studies made *sur le motif* during her summer travels in Italy in 1959 and is a vivid recollection of a sunny day on the plains around Siena. The heat was so intense, recalls the artist, and the experience so powerful, 'It shattered any possibility of a topographical rendering of it … the facts of local colour were quite unimportant. The important thing was to get an equivalent sensation on the canvas.'[16] Here Seurat's dots are so large and regularised that they nearly overcome the individual forms they depict and convey a pulsating, brilliant luminosity and chromatic punch that would become a hallmark of Riley's later colour abstractions (see *Set Fair*, fig. 24).

It is a testament to the power of Seurat's model that his work, on the one hand, helped at first to launch Riley into colour and, then, in a relatively short amount of time, led her away from colour to black and white. The year after she completed *Pink Landscape*, she made *Hidden Squares*, a fully abstract composition in which tiny squares are embedded in an overall grid of black disks. Although she built this radical composition, as always with a new phase of work, through a concentrated period of drawing ('there are no shortcuts'[17]), it seems an astonishing leap.[18] To arrive at this point, Riley elected to temporarily forfeit colour and all the pleasure of Seurat's exhilarating lesson. She did not restore colour to the work until 1967, and then only after gradually introducing varying shades of grey, as in *Arrest 3*, 1965 (plate 4).

Recently, black on its own has returned in the form of a monumental wall drawing, *Composition with Circles 7* (see plate 9). Riley has found this fundamental element – a simple, transparent circle – so resilient that she has composed seven variations on the wall drawing, and countless studies along the way, beginning in 1997 (fig. 19). Not since the 1960s, with works such as *Study for White Discs*, 1964 (fig. 12), has Riley coaxed from a single colour such complex optical effects. But she now has accomplished that feat on an enormous scale and with a new spatial oscillation created as the

effervescent circles bubble up and across the surface but also advance and recede in depth. When studying the wall drawing, as with *Study for White Discs*, just as we think we have seized upon the organisational system, it eludes us, for, despite the barely perceptible underlying grid, Riley's investigational and intuitive 'method' is only partly apprehended through geometric means. Beneath the artist's shifting circular planes, the wall itself is visually dematerialised, and Riley has masterfully fulfilled a youthful ambition. 'I wish', she boldly told a reporter in 1964, 'someone would give me a big wall to destroy. I mean to make it no longer seem a wall.'[19] There were other premonitions of this move to the wall in the artist's early work. In 1967, when the American abstract painter Ad Reinhardt, who, Riley recalls, gave her much encouragement and 'sterling advice', saw her thirteen-foot-wide painting, *Exposure* (1966, fig. 20), at a New York gallery, he foresaw that working directly on the wall was a temptation, and advised her to stay on the canvas. '*Exposure* is still an easel painting,' says Riley, 'but only just.' The positioning of the new wall drawing in the exhibition within sight of *Black to White Discs*, 1962 (plate 5), her first painting comprised entirely of circular forms, allows visitors to discover connections in the artist's thought across nearly five decades. In 1971, when Riley's fellow painter and writer Andrew Forge attempted to describe what he called the 'optical barrage' produced by Riley's high voltage black and white canvases from the 1960s (and his comments could just as easily be applied to the present wall drawing), he resorted to the example of Seurat: 'To find anything like it one would have to look to the Seurat of *Les Poseuses* [1886–8, The Barnes Foundation, Merion, PA]. Here, in the fall of light on a curved surface, counted out in a determined notation of orange and blue dots, there is a similar miraculous meeting of physical sensation and thought-determined system.'[20]

In addition to her early application of Seurat's method, Riley is attentive to the underlying organisation of his compositions: 'Interval follows event: measure, rhythm and cadence all played their part in Seurat's impeccable structure.'[21] Even when considering a work from much later in Riley's career, such as her curve painting from 2005, *Painting with Two Verticals 3* (fig. 21), one can

Fig. 21
Bridget Riley
Painting with Two Verticals 3, 2005
Oil on linen, 193.5 × 263.5 cm
Private collection, USA

draw parallels, however unintentional, with the little *Bridge at Courbevoie* (fig. 15). In 2004, Riley had introduced straight edges into her curve paintings, forming vertical registers that partly hold in check the powerful diagonal momentum of her tapered, curving forms (see also plates 7, 8 and 10). Seurat established at regular intervals strong vertical elements – masts, smokestack, figures, tree – which are reinforced by their reflections in the water and crossed by the strict horizontals of the jetty and the distant bridge. The beautifully taut silhouette of Seurat's sail, which could be a template for Riley's scimitar-shaped curves, is countered by the bending tree at the far right, a tree that finds its abstract counterpart in the swayback curve of yellow in Riley's canvas. In each there is a strong diagonal component: the downward slope of Seurat's grassy river embankment and the diagonal sweep that rises from left to right in Riley's abstraction. There is as well a similarity in mood in the two works, of reverie evoked by forms bathed in soft light, and Riley's colour scheme of blue, green, yellow and orange owes much to her love of Impressionist and Post-Impressionist painting. Even in her most recent curve paintings, the introduction of a new element – horizontals that frame the perimeter – calls to mind Seurat's startlingly modern painted borders. But in one significant way the painters part company. The mysterious quality of stasis in Seurat's work finds few parallels in the elusive, ever fluctuating forms of Riley's paintings. Perhaps for the painterly antecedents of these qualities in her work, one can turn to the example of two other French Modernists she highly reveres, Cézanne and Matisse.

Riley's impassioned advocacy of the art of painting has taken many forms. Well before the current fashion of artist-curated exhibitions, she took time away from the studio to co-organise exhibitions devoted to artists whose work she had a personal connection to, including surveys of Piet Mondrian at Tate in 1997 and Paul Klee at the Hayward Gallery in 2002.[22] For *The Artist's Eye* in 1989, she brought together seven large figure compositions from the National Gallery's collection by artists who used colour in plastic terms, 'as an element of construction'.[23] Her selection began with Titian

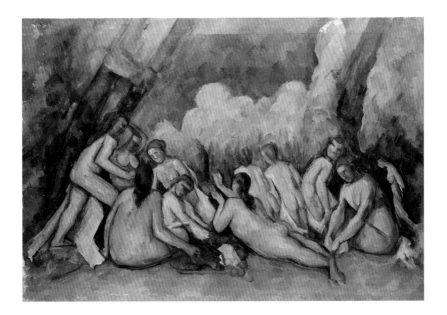

Fig. 22
Paul Cézanne (1839–1906)
Bathers (Les Grandes Baigneuses),
about 1894–1905
Oil on canvas, 127.2 × 196.1 cm
The National Gallery, London
Purchased with a special grant and the aid
of the Max Rayne Foundation, 1964
(NG 6359)

and ended with *Bathers (Les Grandes Baigneuses)* by Cézanne (fig. 22), the only modern work in the group, and the reasons behind her choices are elucidated in an extensive interview in the catalogue. Riley's work, it seems fair to say, has been nourished as much by Cézanne as any artist she has studied in depth, a veneration reinforced by the impressive Cézanne holdings in London museums, the artist's pilgrimages to exhibitions of his work and, significantly, her own part-time residency in the South of France. She never chose to copy Cézanne – she found his manner less accessible than Seurat's – but her insights into the work, based on close observation and recorded in her extensive writings and interviews, illuminate the work from the inside with remarkable painterly insight. The National Gallery's magisterial work *Bathers (Les Grandes Baigneuses)* is Cézanne's grand, late manifesto of the timeless theme of harmony between man and nature, all bathed in his beloved Mediterranean light. One author has recently suggested that these idyllic bathers belong to Cézanne's 'Arcadian repertory' of Provence that he struggled to establish over a lifetime.[24] Perhaps it is in this spirit that Riley's 2007 wall painting included here has acquired an additional title, *Arcadia I* (plate 8 and fig. 6).

Although Cézanne devoutly believed that artists must first train themselves through the study of nature, he was of course a dedicated student of art history. He made many copies in the Louvre, which he called 'the book in which we learn to read', and he drew upon the work of the painters he studied there – Veronese, Rubens and Delacroix – for his early painting *The Feast*, about 1867–72 (a painting much admired by Riley and, coincidentally, begun by Cézanne at the same age she took on Seurat's *Bridge*). When the enthusiastic critic Gustave Geffroy saw the work in 1895, at Cézanne's first solo show at the Galerie Vollard in Paris, he noted these artistic forebears but recognised the painting not as passive transcription but as a work of individual expression: 'This is not a servile admiration, it is a profession of faith, the declaration of a new artist swearing allegiance to painting, to opulence, to energy. It is respectful of past masters, but how ardently it wants to speak in its own turn!'[25]

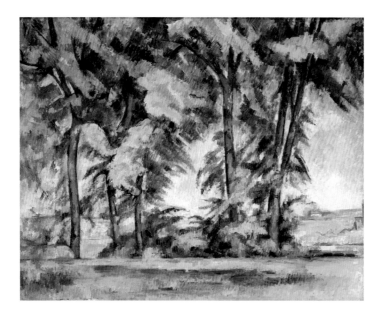

Riley's serious interest in Cézanne has developed over a lifetime. She told Richard Shiff, for example, that she was drawn to the Courtauld's *Tall Trees at the Jas de Bouffan* (fig. 23) by the late 1950s. In his verdant depiction of the family estate through tall, foliated trees, Cézanne painted the canvas with varying degrees of finish, but in the most densely worked areas his parallel strokes form distinctive sequences and patterns, vertical in the lower regions and diagonal in upper leafy zones. These ordered strokes, however independent of the forms they depict, persuasively convey the textures of nature and impart a shimmering quality of coloured light, realising in paint what Cézanne described as 'the vibration of the sensations reflected through the good sun of Provence'.[26] Part of the painting's appeal for Riley lay in the larger compositional diagonals and the palpable 'directional pull' that results when Cézanne's constructive strokes run counter to them.[27]

Riley is especially mindful of diagonals, a compositional mainstay throughout much of her work but particularly since 1985, when, in search of a way to multiply the visual rhythms in her compositions, elaborate the colour activity and encourage the eye to scan the painting in multiple directions, she discontinued the compositions based on vertical bands of colour (see plate 6) and embarked on her rhomboid or so-called 'zig' paintings, including *Set Fair*, 1989 (fig. 24). The vertical element remains but is here determined by parallel stacks of multi-coloured, interlocking lozenge shapes that travel from the bottom left of the canvas to the top right in a dazzling, ceaseless motion. Drawing, as in Cézanne, is achieved not by line, but by colour. Creating their own 'directional pull', Riley's irregularly dispersed colours, punctuated by brilliant white forms, course up and across the surface, shifting in space depending on neighbouring hues to generate optically vibrant patterns and a sparkling prismatic effect. Like Cézanne's patches of colour, these chromatic vibrations convey through paint the continuing flux of observed natural phenomena or what Riley has described as 'the changing pulse of our experience'.[28] To come to terms with the dizzying organisational complexity of Riley's zig paintings one could invoke Roger Fry's description of Cézanne's celebrated *Portrait of*

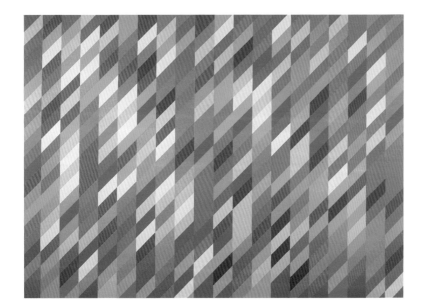

Fig. 24
Bridget Riley
Set Fair, 1989
Oil on linen, 165.5 × 227.2 cm
Courtesy Cranford Collection

Gustave Geffroy from 1895–6 in the Musée d'Orsay: 'The mind of the spectator is held in a kind of thrilled suspense by the unsuspected correspondences of all these related elements. One is filled with wonder at an imagination capable of holding in so firm a grasp all these disparate objects, this criss-cross of plastic movements and directions.'[29]

In 2002, Riley observed to the artist and writer Lynn MacRitchie, 'I was still thinking about Cézanne when I became aware of the Matisse connections.'[30] Given her involvement with colour, the graceful arabesques of the new curve paintings she began in 1998, as well as the collage methods she has employed to prepare her work since 1980, it is no surprise that Riley's work invites comparisons with Matisse. When an interviewer commented in 1995 that she seems to express greater affinity for artists who work figuratively than for the leading abstract painters (though notable exceptions include Mondrian and Jackson Pollock), Riley replied that abstract art should be as 'resourceful and expressive as the great figurative art of the past', and added that Matisse's use of colour in his Fauve paintings and paper cut-outs was far more abstract than that of the most innovative abstract artists. 'If Abstraction is going to win its case and prove its viability,' she argued, 'it has to be more concerned with real issues of painting than with concepts and theories.'[31]

In a short essay from 1990 on Matisse's *Dance II*, 1909–10 (fig. 25), Riley focused on the 'rhythmic organisation' and the 'huge curves and diagonals' as sources of the work's expressive power. Along with the intense red hues, boldly silhouetted against a blue background, these are formal characteristics the Matisse inevitably shares with a work such as Riley's *Red with Red I* (plate 7), which is not to say that *Dance II* was a starting point for the work any more than Cézanne's bathers. Nevertheless, when referring to her own painting, Riley returns to words like pace, movement, rhythm, cadence, speed – slow and fast – terms that apply to dance as well as to the compositional devices that govern her work. Suggesting a kind of abstracted *contrapposto*, the curves of Riley's paintings first move in one direction and then gracefully arch back in a counter curve, as one form

Fig. 25
Henri Matisse (1869–1954)
Dance II, 1909–10
Oil on canvas, 260 × 391 cm
The State Hermitage Museum,
St Petersburg (9673)

seems to precipitate the movement of an adjacent form. Acceleration and syncopation are controlled by the size and frequency of the elements, the number of colours, and the vertical intervals, which are subtly indicated but firmly perceived. These vertical divisions, as in *Painting with Two Verticals 3* (fig. 21), resonate with the abstract background Matisse introduced in the dance mural made for the Barnes Foundation (fig. 26), and like Matisse's dancers, Riley's tapered curves move across the straight-edged boundaries to keep the upward diagonal thrust in play.

 A key difference with Matisse is the complex interplay of image and ground that animates Riley's curve paintings. This interest reflects her own recent preoccupation with opening the picture boundaries to the wall, a seemingly dramatic step that has gradually evolved through the intricate working process she has devised to compose her paintings, involving pre-cut pieces of painted paper, both for preparatory drawings as well as full-scale cartoons. Clearly demonstrated in her *Collage Study*, 2005 (fig. 9), as Riley wove and layered the cut paper, some shapes extend beyond the rectangular border. At the same time she introduced white into her colour abstractions and began to open these areas directly to the white support, dissolving the boundaries between inside and outside. From there it seemed a 'natural step' to dispense with the canvas altogether and incorporate the wall. Her challenge of late is to close off the edge again, corral her forms and, as she has said, 'to get it all together as an easel painting, albeit a large one'. Hence, a new pictorial solution arrived with *Blue (La Réserve)* (plate 10), in which the tips of the curves lightly intersect or cross over and under the newly introduced horizontal bands that run parallel to the canvas edge. For Matisse, what began also as a preparatory method, the *papiers découpés*, became an end in itself in the last decade.[32] The technique could lead to works of astonishing simplicity and abstraction, particularly when used in a decorative context. In his *L'Arbre de Vie*, the final maquette for the nave windows he designed for the chapel at Vence, the stylised leaves, set in a diagonal orientation seem to presage Riley's curved shapes.

Fig. 26
Henri Matisse (1869–1954)
The Dance, summer 1932 – April 1933
Oil on canvas, 339.7 × 441.3 cm, 355.9 × 503.2 cm, 338.8 × 439.4 cm
The Barnes Foundation, Merion, Pennsylvania (2001.25.20)

In 'Observations on Painting', his statement from 1945 written at the age of seventy-six, Matisse exhorts young artists to revere the past while finding their own way, citing Cézanne's devotion to Delacroix and Poussin.[33] Like Cézanne, Matisse had learned through copying in the Louvre as a student, but he periodically continued the practice later in his career. In 1915 he famously reiterated, and completely transformed, his own rendition of Jan Davidsz. de Heem's *A Table of Desserts*, 1640, made in the Louvre in 1893 – as unlikely a choice in retrospect as Riley's selection of van Eyck.[34] Also in 1915, Matisse made a lithograph, *Fruits and Foliage (after Cézanne)*, diligently following a small oil by Cézanne that he owned. Though he did not reproduce it, of inestimable importance to him was another Cézanne in his collection, *Three Bathers*, 1879–82 (now in the Petit Palais, Paris) which he acquired from Ambroise Vollard in 1899 and kept, despite temptations to sell during moments of financial difficulty. When he finally chose to donate it to a Paris museum thirty-seven years later, his account of its significance is a moving tribute paid by a mature artist to his lifelong mentor: 'It has sustained me morally in the critical moments of my venture as an artist. I have drawn from it my faith and my perseverance.'[35] That Riley, in her words, 'drew courage' from Matisse and came to him in part by way of Cézanne, is a fitting lineage within the modern French tradition she so values.[36] In her lecture from 1996, 'Painting Now', much of it devoted to the extraordinary legacy of Matisse, Riley concluded, 'From the viewpoint of the modern painter the true tradition lies less in a succession of solutions than in recognising that the problems of picture-making can never be solved as such. And it is just this that constitutes painting's continuing vitality.'[37] Viewing Riley's work within the rich context of the history of European painting in the National Gallery, not only enhances our understanding of her contribution, but will no doubt produce new, unforeseen connections with the painters who came before her. As Cézanne said, 'One doesn't replace the past, one only adds a new link to it.'[38]

NOTES

1 Bridget Riley, 'Foreword', *The Eye's Mind: Bridget Riley. Collected Writings 1965–2009*, ed. Robert Kudielka, London 2009 (revised edn), p. 11.

2 Unless otherwise noted, quotations are from the author's conversations with the artist held in June 2010.

3 Bridget Riley, 'The Experience of Painting, talking to Mel Gooding' (1988) in *The Eye's Mind*, 2009, p. 147.

4 Bridget Riley, 'Personal Interview by Nikki Henrique' (1998) in *The Eye's Mind*, 2009, pp. 30–1.

5 Bridget Riley, 'From Life' in Bridget Riley and Paul Moorhouse, *Bridget Riley: From Life*, exh. cat., National Portrait Gallery, London 2010, p. 9.

6 The exhibition, *Fra Angelico to Leonardo: Italian Renaissance Drawings*, was held at the British Museum, London, 22 April – 25 July 2010.

7 See *Bridget Riley: From Life*, 2010, p. 7.

8 Bridget Riley, 'Holidays. Talking to Vanya Kewley' (1996) in *The Eye's Mind*, 2009, p. 45.

9 Bridget Riley, 'Seurat as Mentor' in Jodi Hauptman, *Georges Seurat: The Drawings*, exh. cat., Museum of Modern Art, New York 2007, p. 188.

10 Bridget Riley, 'In Conversation with Lynne Cooke' (2005) in *The Eye's Mind*, 2009, p. 314.

11 Robert Kudielka, 'In Search of a Direction: Bridget Riley's Work in the 1950s' in Jonathan Crary, Nadia Chalbi and Robert Kudielka, *Bridget Riley: Retrospective*, exh. cat., Musée d'Art moderne de la Ville de Paris, Paris 2008, p. 56.

12 Meyer Schapiro, 'Seurat' (1958) in *Modern Art 19th & 20th Centuries, Selected Papers*, New York 1982, p. 103.

13 Bridget Riley, 'The Artist's Eye: Seurat' (1992) in *The Eye's Mind*, 2009, p. 272 note.

14 Riley revised and extended this lecture, delivered at Darwin College, Cambridge, for her essay, 'Colour for the Painter' (1995) in *The Eye's Mind*, 2009, pp. 222–48.

15 Félix Fénéon quoted by Riley in 'Seurat as Mentor', 2007, p. 185. Riley first recalled Fénéon's words in an interview, 'The Experience of Painting, talking to Mel Gooding' (1988) in *The Eye's Mind*, 2009, p. 147.

16 Bridget Riley, 'In Conversation with Bridget Riley' in Maurice de Sausmarez, *Bridget Riley*, Greenwich CT 1970, p. 57.

17 Bridget Riley, 'Work' (2009) in *The Eye's Mind*, 2009, p. 57.

18 Riley describes this process in 'Seurat as Mentor', 2007, pp. 189–91.

19 Bridget Riley, quoted in 'Art: Something to Blink At', *Time*, 1 May 1964. The article was a review of a group show, *The New Generation*, at the Whitechapel Gallery, London.

20 Andrew Forge, 'On Looking at Paintings by Bridget Riley', *Art International*, vol. 15, no. 3 (1971), p. 19.

21 Bridget Riley, 'The Artist's Eye: Seurat' (1992) in *The Eye's Mind*, 2009, p. 273.

22 *Mondrian: Nature to Abstraction* was co-organised by Riley with Tate curator Sean Rainbird. *Paul Klee: The Nature of Creation* was selected with Robert Kudielka.

23 Bridget Riley, 'Bridget Riley in conversation with Robert Kudielka: The Colour Connection' in *The Artist's Eye: Bridget Riley*, exh. cat., National Gallery, London 1989, p. 7.

24 See Nina Maria Athanassoglou-Kallmyer, *Cézanne and Provence: The Painter in His Culture*, Chicago and London 2003, pp. 196–231.

25 Gustave Geffroy, quoted in Françoise Cachin *et al.*, *Cézanne*, exh. cat., Tate Gallery, London, Grand Palais, Paris, Philadelphia Museum of Art, London 1996, p. 104.

26 Paul Cézanne, letter to Henri Gasquet, 3 June 1899, quoted in Benedict Leca, 'Sites of Forgetting: Cézanne and the Provençal Landscape Tradition' in Philip Conisbee and Denis Coutagne, *Cézanne in Provence*, exh. cat., National Gallery of Art, Washington DC 2006, p. 53. Riley's 2006 review of this exhibition for *The Burlington Magazine* is reprinted in *The Eye's Mind*, 2009, pp. 249–65.

27 See Riley in Richard Shiff, 'Bridget Riley: The Edge of Animation' in *Bridget Riley*, ed. Paul Moorhouse, exh. cat., Tate, London 2003, p. 87.

28 Bridget Riley, 'According to Sensation, in conversation with Robert Kudielka' (1990), *The Eye's Mind*, 2009, p. 142.

29 Roger Fry, *Cézanne: A Study of His Development*, New York 1927, p. 70 (quoted in John Rewald, 'Catalog' in *Cézanne: The Late Work*, ed. William Rubin, exh. cat., Museum of Modern Art, New York 1977, p. 386).

30 Bridget Riley in Lynn MacRitchie, 'The Intelligence of the Eye' in *Bridget Riley: New Work*, ed. Martin Hentschel, exh. cat., Museum Haus Esters and Kaiser Wilhelm Museum, Krefeld 2002, p. 19.

31 Bridget Riley, 'Something to Look At, in conversation with Alex Farquharson' (1995) in *The Eye's Mind*, 2009, p. 156.

32 Riley discussed the importance to her of Matisse's *papiers découpés* in 'In conversation with Lynne Cooke' (2005) in *The Eye's Mind*, 2009, p. 315.

33 Henri Matisse, 'Observations on Painting' (1945) in Jack Flam, *Matisse on Art*, Berkeley and Los Angeles 1995, pp. 157–9.

34 The two works by Matisse are *La desserte (after Jan Davidsz. de Heem)*, 1893, Musée Matisse, Nice, and *Still Life after Jan Davidsz. de Heem's 'La desserte'*, 1915, Museum of Modern Art, New York.

35 Henri Matisse, in a letter to Raymond Escholier, director of the Musée du Petit Palais, Paris, 10 November 1936, quoted in Flam, *Matisse on Art*, 1995, p. 124. The installation of the 2010 exhibition, *Matisse: Radical Invention 1913–1917*, organised by the Art Institute of Chicago and the Museum of Modern Art, New York, began with this work by Cézanne.

36 Bridget Riley in MacRitchie, 2002, p. 19.

37 Bridget Riley, 'Painting Now' (1996) in *The Eye's Mind*, 2009, p. 302.

38 Paul Cézanne, letter to Roger Marx, 23 January 1905, in 'Cézanne on Art' in Cachin *et al.*, 1996, p. 17.

Plates

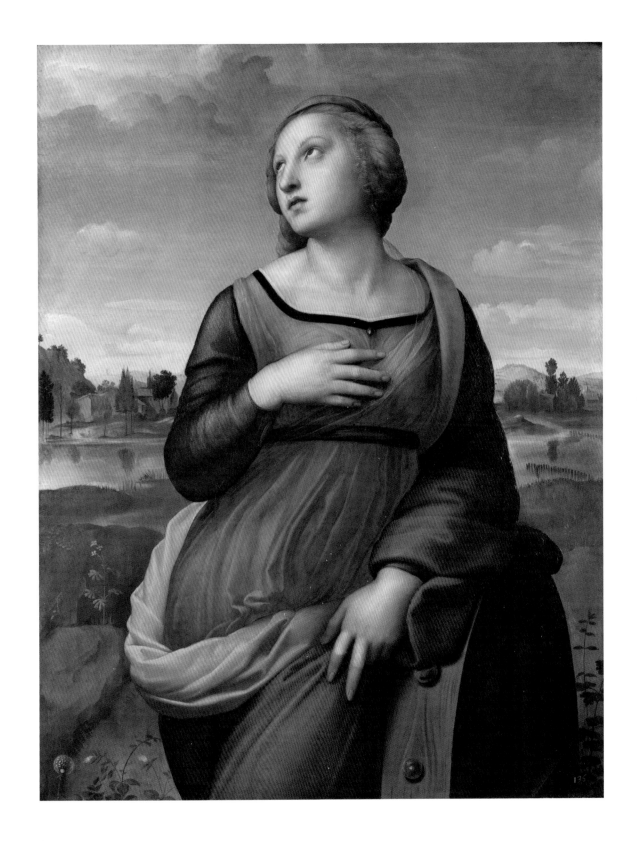

1
Raphael (1483–1520)
Saint Catherine of Alexandria, about 1507
Oil on poplar, 72.2 × 55.7 cm
The National Gallery, London (NG 168)

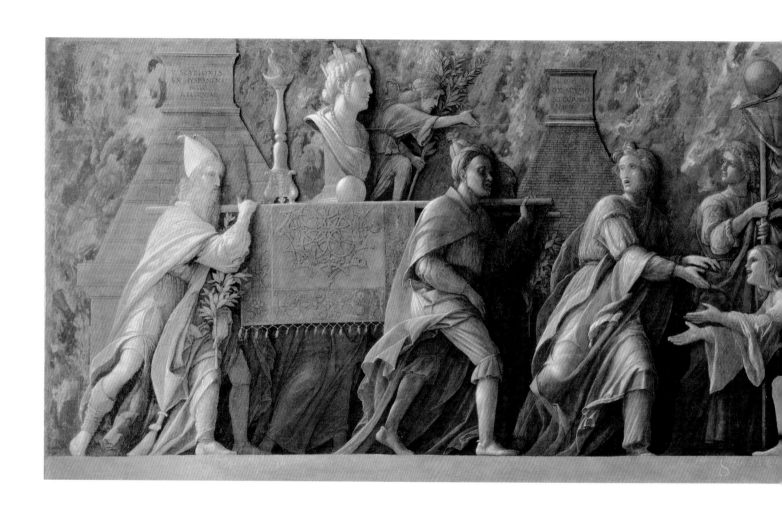

2
Andrea Mantegna (about 1430/1–1506)
The Introduction of the Cult of Cybele at Rome, 1505–6
Glue on linen, 73.7 × 268 cm
The National Gallery, London (NG 902)

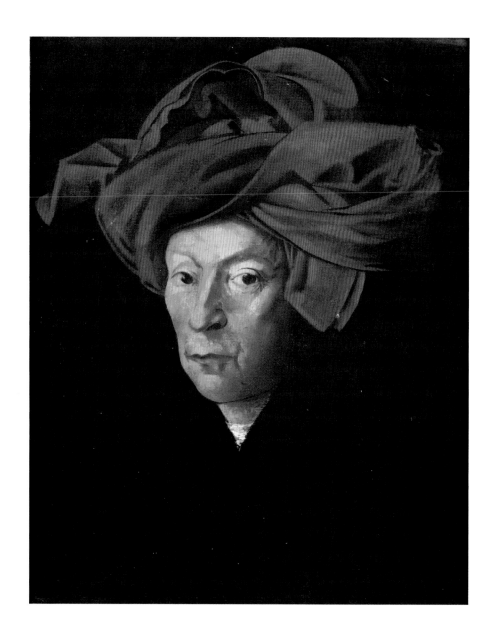

3
Bridget Riley
Man with a Red Turban (After van Eyck), 1947
Oil on canvas, 66 × 56 cm
Private collection, Germany

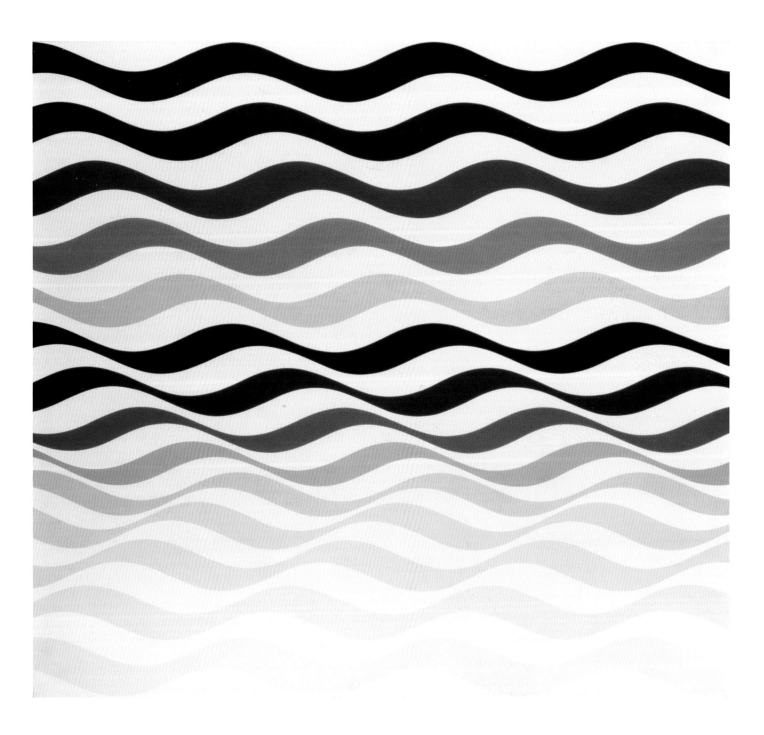

4
Bridget Riley
Arrest 3, 1965
Acrylic on linen, 175 × 192 cm
Gallery of Modern Art, Glasgow

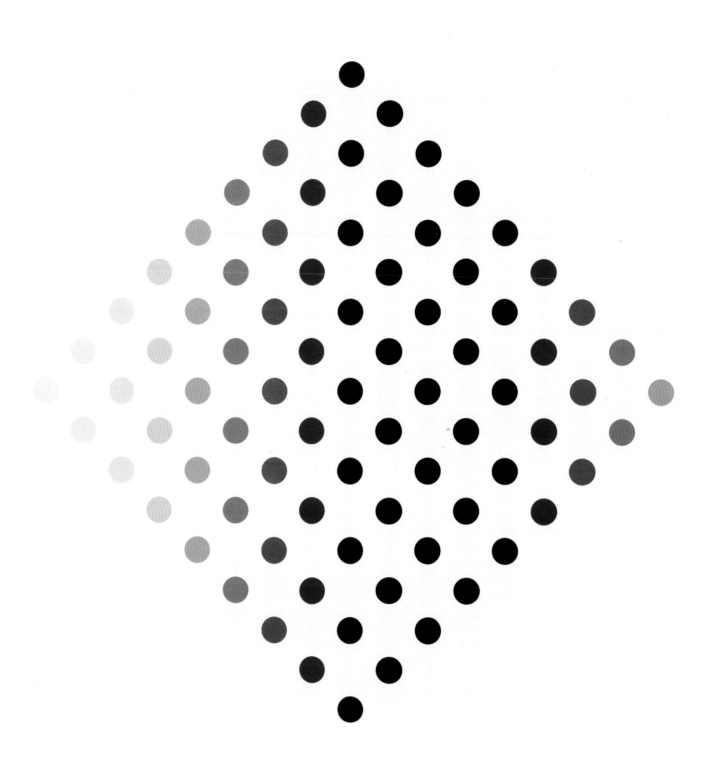

5
Bridget Riley
Black to White Discs, 1962
Acrylic on canvas, 178 × 178 cm
Private collection

6
Bridget Riley
Saraband, 1985
Oil on linen, 166.5 × 136.5 cm
Private collection

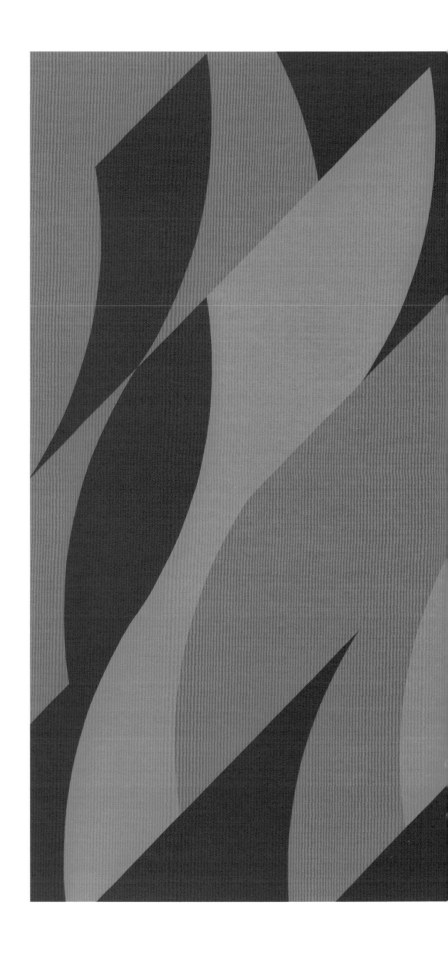

7
Bridget Riley
Red with Red 1, 2007
Oil on linen, 177.5 × 255 cm
Private collection

overleaf
8
Bridget Riley
Arcadia 1 (Wall Painting 1), 2007, installation view,
Galerie Max Hetzler, Berlin
Graphite and acrylic on wall, 266.5 × 498.5 cm
Private collection

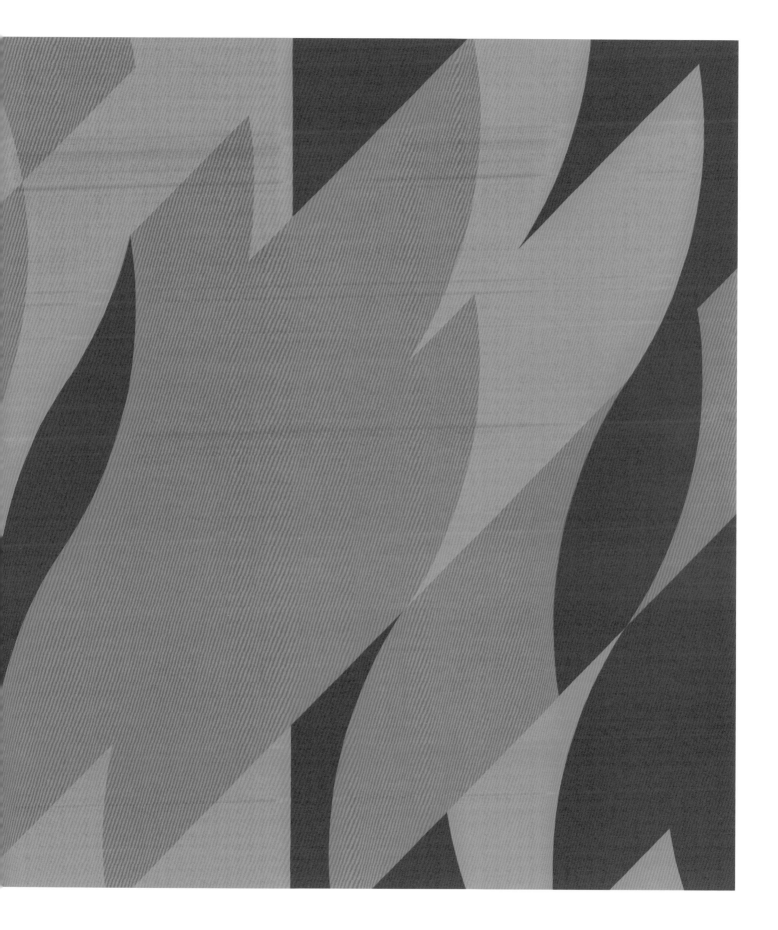

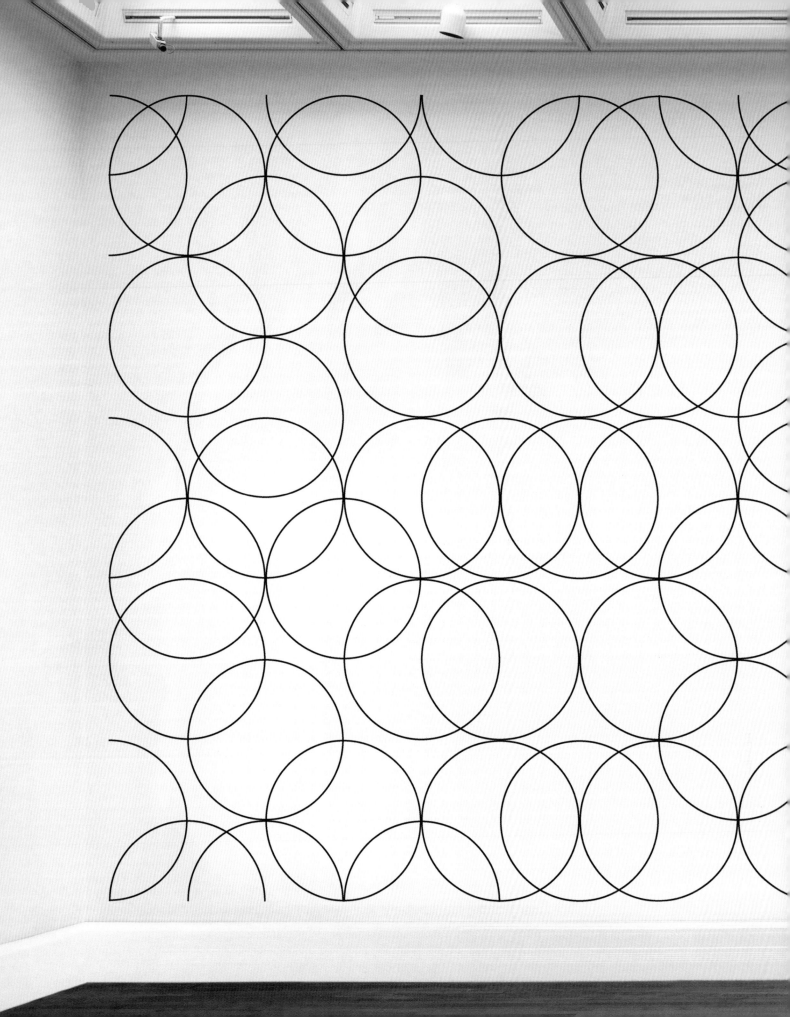

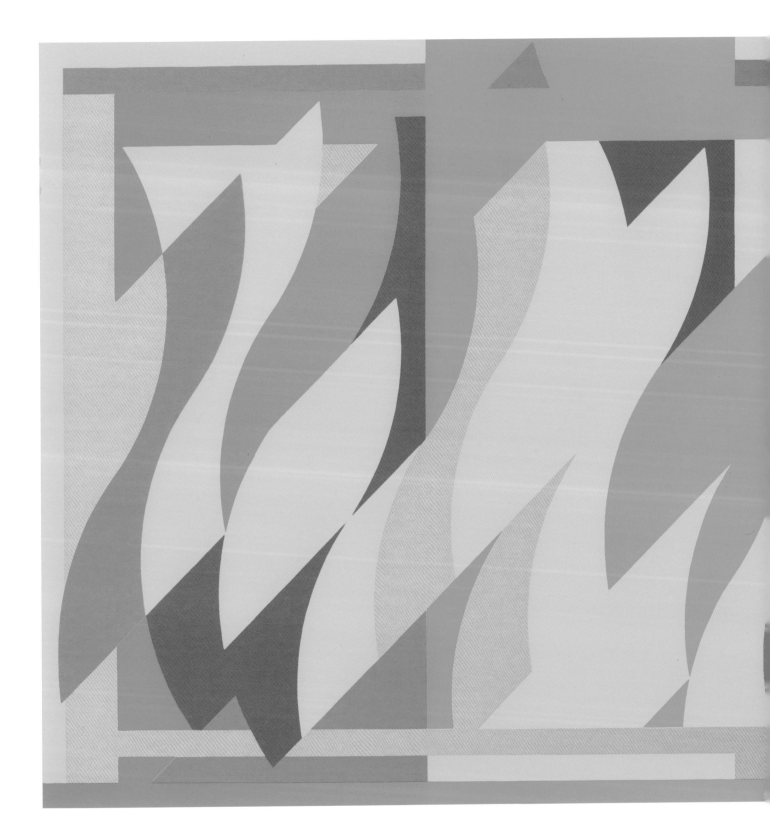

10
Bridget Riley
Blue (La Réserve), 2010
Oil on linen, 183 × 381 cm
Private collection

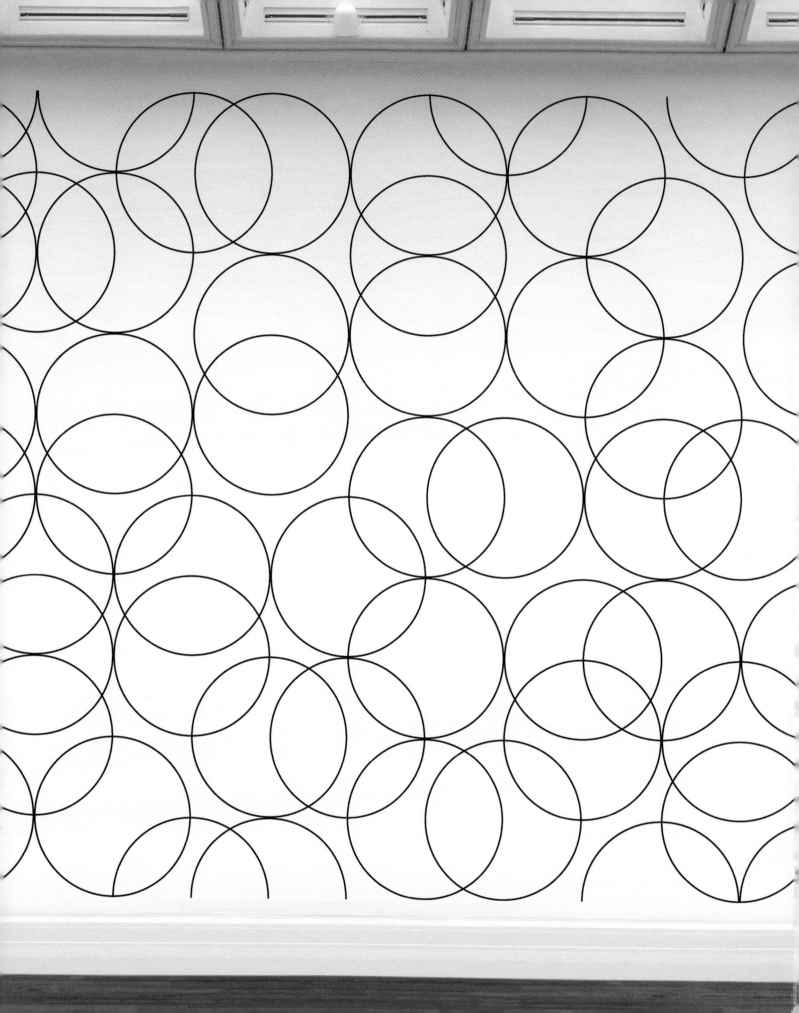

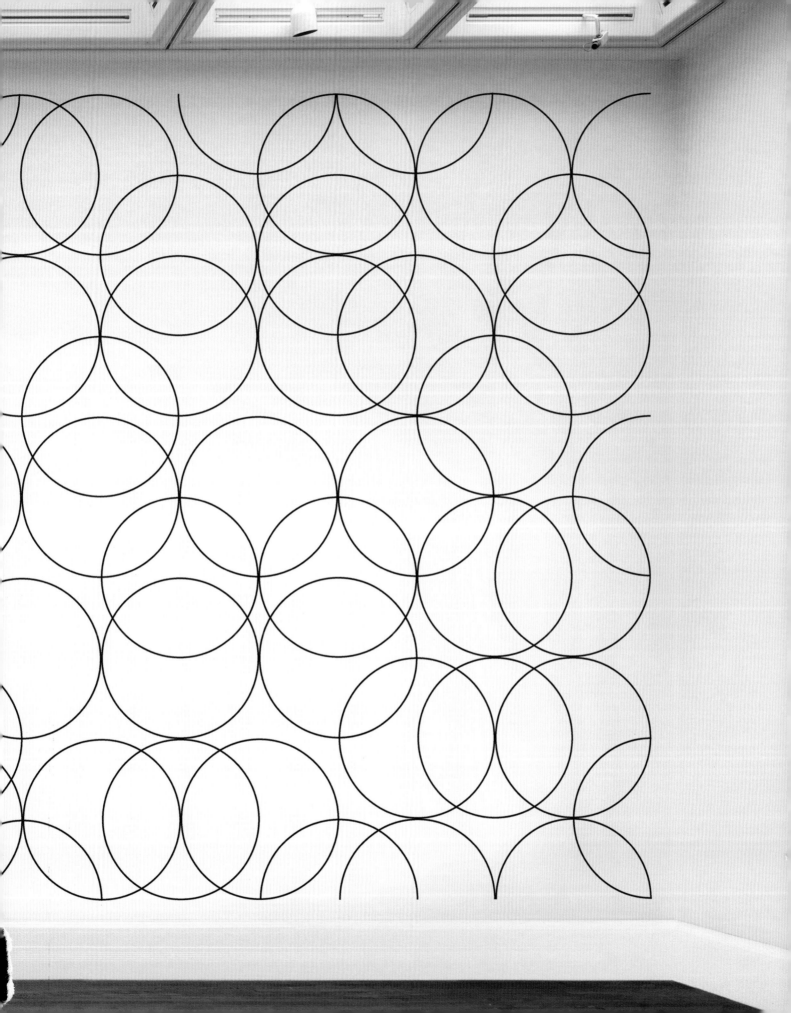

9
Bridget Riley
Composition with Circles 7, 2010 [mock-up, work in progress]
National Gallery, London
Graphite, acrylic paint and permanent marker on plaster wall, 492.5 × 1,379 cm
(diameter of circle 98.5 cm)
Private collection

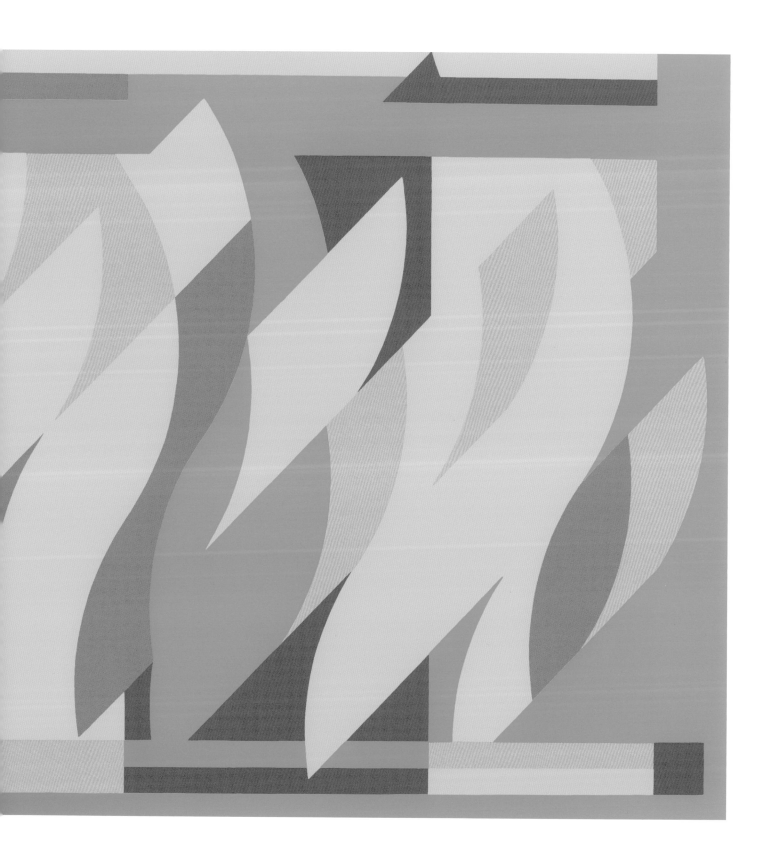

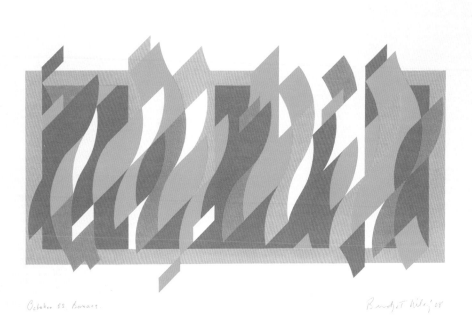

11
Bridget Riley
October 22nd Bassacs, 2008
Gouache on paper,
61.5 × 94.5 cm
Private collection

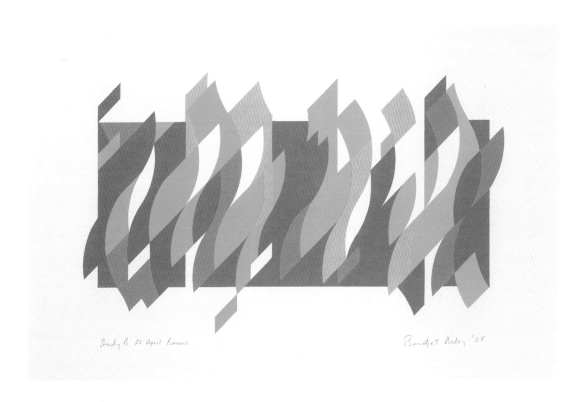

12
Bridget Riley
Study B. 22nd April Bassacs,
2008
Gouache on paper,
61.6 × 93.3 cm
Private collection

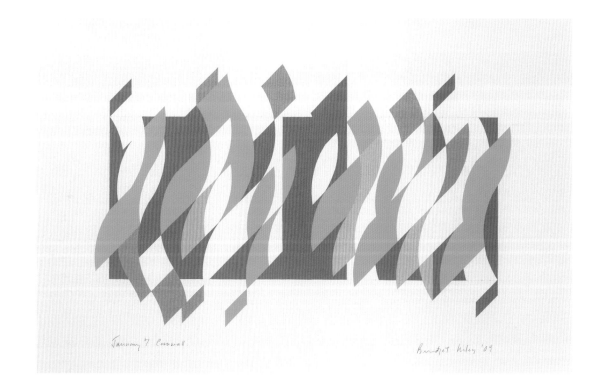

13
Bridget Riley
Jan 7th Cornwall, 2009
Gouache on paper,
61.5 × 95.5 cm
Private collection

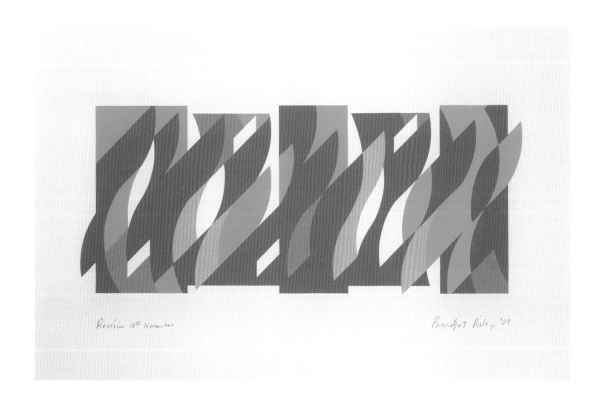

14
Bridget Riley
Revision 10th November,
2009
Gouache on paper,
58.3 × 92.7 cm
Private collection

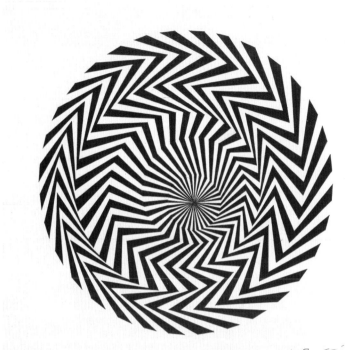

'62 Bridget Riley

15
Bridget Riley
Study for Blaze, 1962
Gouache on paper, 40 × 40.4 cm
Private collection

Bridget Riley '63
Scale study for Shift

16
Bridget Riley
Scale study for 'Shift', 1963
Gouache on paper, 36.7 × 61.6 cm
Private collection

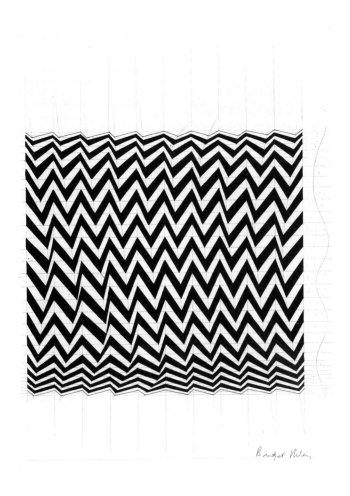

17
Bridget Riley
Study for Fragments Print 3, 1965
Gouache and pencil on paper, 50.8 × 36.2 cm
Private collection

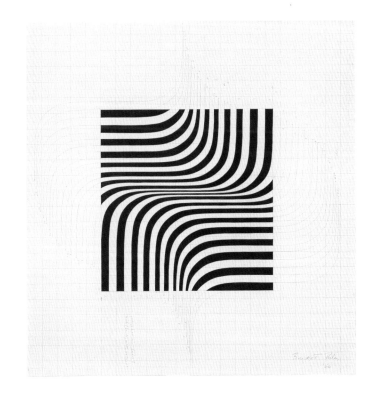

18
Bridget Riley
Untitled (Right Angle Curve), 1966
Gouache on graph, 58.8 × 55.9 cm
Private collection

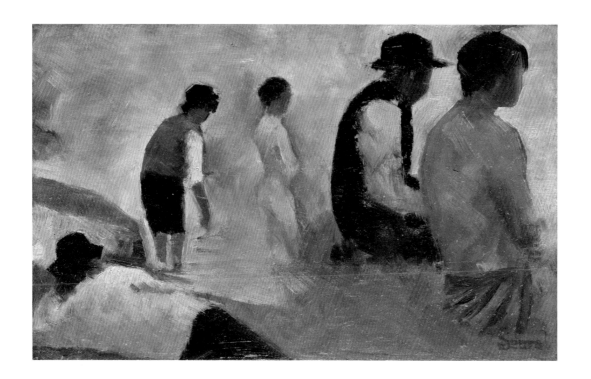

19
Georges Seurat (1859–1891)
Study for 'Bathers at Asnières', 1883–4
Oil on wood, 15.2 × 25 cm
The National Gallery, London
(NG 6561)

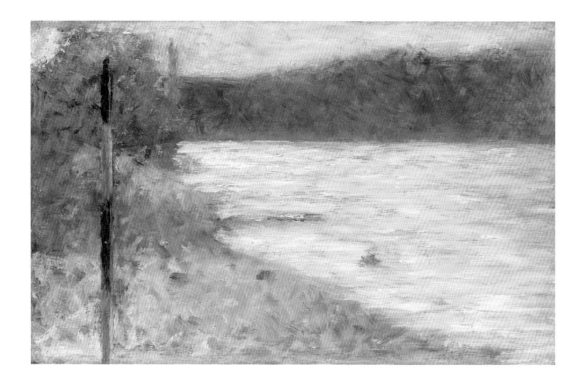

20
Georges Seurat (1859–1891)
A River Bank (The Seine at Asnières), about 1883
Oil on wood, 15.8 × 24.7 cm
The National Gallery, London (NG 6559)

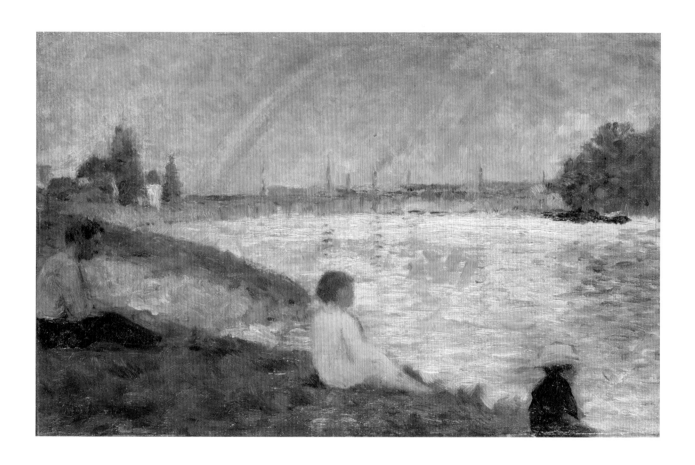

21
Georges Seurat (1859–1891)
The Rainbow: Study for 'Bathers at Asnières', 1883
Oil on wood, 15.5 × 24.5 cm
The National Gallery, London (NG 6555)

Robert Kudielka

Chronology

1931
Born in London.

1939–45
Childhood in Cornwall. While her father is away in the armed forces during the war Bridget Riley lives with her mother, younger sister and aunt (a former student of Goldsmiths' College, London) in a cottage not far from the coast near Padstow. Irregular primary education by non-qualified or retired teachers who from time to time assemble children in the locality for lessons in subjects in which they have knowledge or interest. The beginning of Riley's interest in nature.

1946–8
Education at Cheltenham Ladies' College. Thanks to an understanding headmistress she is allowed to organise her own curriculum, and chooses only art lessons in addition to obligatory subjects. Her teacher, Colin Hayes, later tutor at the Royal College of Art, London, introduces her to the history of painting and encourages her to attend the life class at the local art school. The Van Gogh exhibition at the Tate Gallery in 1947 is her first encounter with the work of a modern master.

1949–52
Studies at Goldsmiths' College, London. For her entrance examination she submits, among other works, a copy of

Jan van Eyck's *Portrait of a Man (Self Portrait?)*. She devotes herself mainly to the life-drawing class of Sam Rabin, whom she still remembers with respect because he introduced her to the principles of pictorial abstraction: the autonomous construction of a body on a flat plane. Later she says: 'Life drawing was about the only thing I ever learned at art school.'

1952–5
Studies at the Royal College of Art. A period of great frustration, partly because it is her first experience of the art scene in London, partly because she slowly sees herself confronted with the unavoidable basic question of the modern painter: 'What should I paint, and how should I paint it?' Among her contemporaries are Frank Auerbach, Peter Blake, Robyn Denny, Richard Smith and Joe Tilson. She graduates with a BA degree.

1956–8
Continuation of a long period of unhappiness. She nurses her father after a serious car accident and suffers a breakdown. Works in a glassware shop, teaches children and eventually joins the J. Walter Thompson advertising agency where her job is principally to draw the subjects which form the basis of the photographer's work. In the winter of 1958 she sees the Whitechapel Gallery's large Jackson Pollock exhibition, which makes a powerful impact.

Fig. 27 Bridget Riley in her west London studio, 1960s 67

1959

Stimulated by the exhibition *The Developing Process* at the Institute of Contemporary Arts (March to April), a joint project on the creative process, devised by Harry Thubron and Victor Pasmore, she takes part in Thubron's summer school in Suffolk, where she meets Maurice de Sausmarez, who becomes her friend and mentor for the next few years and who will write the first monograph on her work. The older painter and art scholar arouses her interest in Futurism and Divisionism and introduces her to primary documents of modern art (Klee, Stravinsky). In the late autumn she copies Georges Seurat's *Le Pont de Courbevoie* (Courtauld Institute, London) from a reproduction.

1960

First year of her independent work. In the summer she and de Sausmarez tour Italy, admiring the architecture. At the Venice Biennale, Riley sees the large exhibition of Futurist works. In the hills surrounding Siena she makes studies for *Pink Landscape*, a key painting in her early development. In the autumn she breaks with de Sausmarez and suffers a personal and artistic crisis. From repeated attempts to make one final, entirely black painting, originate her first black and white works, which to begin with are oriented towards contemporary Hard Edge painting (for example, *Kiss*) but very quickly take on the unmistakable traits of her own pictorial identity.

1961–4

Beginning of the black and white paintings, which she continues until 1966. It is a period of intense work. Peter Sedgley, a painter of her own generation, remains her partner throughout the 1960s. In the summer, both visit the plateau of Vaucluse in the South of France where she acquires a derelict farm which in the 1970s is transformed into her new studio. In London, one evening on her way home from J. Walter Thompson (where she works part-time until 1962) she shelters from a downpour in a doorway – it turns out to be the entrance of Gallery One, whose director, Victor Musgrave, asks her in. She invites him to visit her studio to look at her work. In the following spring Musgrave holds her first solo exhibition.

1965

Increasing recognition culminates in the inclusion of her work in the exhibition *The Responsive Eye* at the Museum of Modern Art, New York, in January. Richard Feigen simultaneously opens a solo show of her work, which is sold out before the opening night. Josef Albers calls her his 'daughter' and Ad Reinhardt acts as her escort, to protect her from 'wolves'. She has become a 'star', to whom even Dalí, together with his royal retinue and real leopards, pays tribute. But her success is double-edged. Fashion shop windows are full of 'Op' imitations of her work. With the help of Barnett Newman's lawyer she tries to take legal action against this commercial plagiarism, only to discover that in the USA there is no copyright protection for artists. Leading New York artists, realising the dangerous implications of this, start their own independent initiative. As a result, in 1967 the first US copyright legislation is passed. Returning to London three weeks after the opening of *The Responsive Eye*, she has only one thought: 'It will take at least twenty years before anyone looks at my paintings seriously again.'

1965–7

Period of transition in which she introduces into her painting sequences of coloured greys, as opposed to the neutral greys she had used earlier. The exceptional subtlety of these pictures and their titles (*Arrest*, *Drift*, *Deny*) carry further the method of reversal by compounding it. In the summer of 1967 she visits Greece. In the same year, with *Chant* and *Late Morning*, she makes her breakthrough to pure colour. Along with the sculptor Phillip King she is chosen to represent Great Britain at the forthcoming Venice Biennale. That winter she meets Robert Kudielka for the first time.

1968–9

Wins the International Prize for Painting at the 34th Venice Biennale. She is the first British contemporary painter and the first woman ever to achieve this distinction. It is also the last prize awarded by the Biennale in its old form. The prize-giving ceremony cannot take place due to student protests. Along with César, Marisol and others, she tries in vain to get into discussion with the students. In the autumn of the same year Sedgley and Riley establish SPACE, an organisation that provides artists with low-cost studios in large warehouse buildings. The project gets successfully underway with the move into St Katherine's Dock in 1969 and still continues, with the support of the Arts Council of England, up to the present day.

1970–1

Large European retrospective which covers the period 1961–70 (including some work prior to 1961) and shows the development from the black and white works to the new colour paintings based on the interplay of only two or three colours. The exhibition opens at the Kunstverein Hannover and subsequently travels to Berne, Düsseldorf, Turin and finally London, where it is extended and presented at the Hayward Gallery. It attracts more than 40,000 visitors. Robert Melville, who had so far followed her development rather critically, begins his review in the *New Statesman* with: 'No painter, dead or alive, has ever made us more aware of our eyes than Bridget Riley.'

1971–3

Beginning of a period of radical artistic change. Her visits to museums and art galleries while accompanying her European retrospective have made her more curious about the European tradition in painting. She undertakes numerous journeys with Kudielka: to see Tiepolo and Riemenschneider in Würzburg; Grünewald in Colmar. She visits the Alte Pinakothek in Munich, where she is deeply impressed by Altdorfer and Rubens, and the Prado in Madrid for the great Spanish painters and, above all, Titian. In such remote places as the Baroque churches of Upper Swabia she unexpectedly finds echoes of the luminous colours she is using at the time. All paths lead irresistibly and recurrently back to the vexing question occupying her in the studio: How to approach colour? At first she tries to extend her means through formal changes, but with *Paean* she changes the formal organisation altogether, a move that anticipates the freer, more open structure of her work in the 1980s. In the spring of 1973, while looking at Altdorfer's cycle of the Passion in the monastery of St Florian near Linz, news reaches her that her mother is suffering from an acute form of myeloma.

1974–7

During the next two years she divides her time between London and Cornwall, to which her parents have retired. She begins to read Proust, who influences her on many levels. She has her property in Vaucluse renovated, but does not use the newly-built studio until the beginning of the 1980s. With the 'curve' paintings, on which she works exclusively between 1974 and 1978, her work takes a lyrical turn quite at odds with prevailing taste. Following the death of her mother

in 1976 she concentrates on the preparation of another retrospective, and in this connection travels to Japan for three weeks at the end of March 1977, with a stopover in India (where she visits the cave temples of Elephanta, Ellora and Ajanta). Her attraction to classical Japanese culture is spontaneous and ranges from painting and formal gardens through to Noh theatre and the hospitality of the *ryokans*. The gallery owner Shimizu gains her entrance to almost all the important sites in and around Kyoto and Nara. In the Osaka Museum she is given permission to study the famous sketchbook of Ogata Korin with his studies of waves.

1978–80

A second retrospective exhibition, with just under 100 paintings covering the years from 1959 to 1978, means that Riley travels extensively again. Opening in Buffalo, New York (September 1978), it continues with two further stops in the USA, two in Australia, and reaches its final destination in Tokyo (January 1980). In December 1977 she sees the exhibition *Cézanne: The Late Work* at the Museum of Modern Art, New York, visiting the show again in Paris the following year. In 1978 the exhibition *Monet's Years at Giverny: Beyond Impressionism* at the Metropolitan Museum, New York, engages her to such an extent that she goes to see it a second time in the autumn in St Louis. En route to the Sydney showing of her own exhibition she visits Tahiti. While in Australia she makes expeditions to the Barrier Reef, Alice Springs and Ayers Rock. She returns home via Indonesia: in Bali she enjoys the rich greens of the country and the extravagant colours of its festivals, especially the Barong theatre; and in Java she is particularly impressed by the pure, cool abstraction of the great temple of Borobudur in the middle of the jungle. Her artistic development takes an unexpected turn in the winter of 1979–80, when she travels, mainly on her sister's initiative, to Egypt. There she is taken by the contrast between the cultivation in the Nile Valley and the monumental works of art on the edge of the desert. In the Cairo Museum she is surprised by the consistent use of a certain group of colours in the arts and crafts of Ancient Egypt; and the tomb paintings on the West Bank of Luxor show her the full extent to which these colours could be developed. But it is only much later, after her return to London, that she recalls the particular palette and begins considering its potential for her own work.

1981–5

The free reconstruction of the 'Egyptian palette' gives her for the first time a basic range of strong colours that, because of their intensity, demand a return to the simpler form of stripes. She begins to work regularly in her studio in Vaucluse and studies the use of colour by the French painters of classical Modernism. In 1981 she is appointed a Trustee of the National Gallery in London. In 1983, for the first time in fifteen years, she visits Venice again to look at the paintings that form the basis of European colourism. She begins to give lectures on her work and accepts two commissions: in 1983 her wall paintings for the Royal Liverpool Hospital are completed. In the same year, the Ballet Rambert gives a first performance at the Edinburgh Festival of the ballet *Colour Moves*, which the American choreographer Robert North created in response to her backcloth designs. In the winter of 1981–2 she travels to Southern India where she visits the major Hindu and Buddhist monuments. During the planning of the extension of the National Gallery in London her role as a Trustee becomes controversial. Almost single-handedly, she brings about the rejection of a commercial project for the new building and clears the way for the present Sainsbury Wing. In 1984 she gradually begins to prepare for a radical revision of her work in her Vaucluse studio, and in the spring of 1986 her painting takes a new direction.

1986–91

In 1986, on the occasion of her latest exhibition at the Sidney Janis Gallery in New York, she meets two postmodern 'appropriation' painters, Philip Taaffe and Ross Bleckner, who have made extensive use of her earlier work. She herself is moving into a new area. The breaking up of the vertical register of her paintings through the introduction of a dynamic diagonal disrupts the balance of her pictorial space and results in larger and smaller units in lozenge form. In order to be able to concentrate fully on the new work she sets up an additional studio in the East End of London. In summer 1989 the National Gallery invites Riley to select the latest in the series of *The Artist's Eye* exhibitions. She chooses seven large figure compositions by Titian, Veronese, El Greco, Rubens, Poussin and Cézanne from the Gallery's collection. They all have in common an organisation shaped by diagonals and are characterised, if in varying degrees, by complex colour orchestrations.

1992–4

In spring 1992 a retrospective, *Paintings 1982–1992*, opens at the Kunsthalle Nürnberg and travels to the Josef Albers Museum, Bottrop; the Hayward Gallery, London, with the sub-title 'According to Sensation'; and the Ikon Gallery, Birmingham. It consists of paintings that cover the transition from the stripe formations to the dynamism of the lozenge structures. The success of the show coincides, particularly in England, with a series of exhibitions focusing on the art of the 1960s. Riley emerges as one of the very few artists of that period who were able subsequently to develop their work. The Tate Gallery in London puts on a Riley display, *Six Paintings 1963–1993*, drawn from its collection. As a result of the renewed interest in Riley's work BBC Radio 3 produces a series of five programmes in which Riley is in conversation with Neil MacGregor, E. H. Gombrich, Michael Craig-Martin, Andrew Graham-Dixon and Bryan Robertson. Broadcast in 1992, they are repeated the following year and published in book form in 1995. The same year she delivers a lecture, 'Colour for the Painter', at Darwin College in Cambridge. Riley is made Honorary Doctor of the Universities of Oxford (1993) and Cambridge (1995).

1995–8

Her painting *From Here* (1984) lends its title to an exhibition of three generations of British abstract painters organised by Karsten Schubert and Waddington Galleries in 1995. After a more than thirty-year absence from teaching, Riley accepts an invitation to join the staff of De Montfort University, Leicester, as Visiting Professor. In 1996 she gives the 23rd William Townsend Memorial Lecture at the Slade School of Fine Art, choosing 'Painting Now' as the subject. Visits to the Mondrian retrospective at the Gemeentemuseum in The Hague in the winter of 1994–5 lead to an intense re-engagement with the work and writings of Mondrian. In November 1995 she contributes a paper to a Mondrian symposium at the Museum of Modern Art, New York. The following year she is asked by the Tate Gallery to select a Mondrian exhibition from the collection of the Gemeentemuseum. Installed by Riley and her co-curator, Sean Rainbird, the exhibition is the first comprehensive Mondrian show in England in forty years. Meanwhile, her own work is showing signs of further change. Having slowly introduced colour harmonies equal to the prevailing contrast structure, she is now working with a new sensation of

'depth'. In spring 1997 she also begins to introduce circular or curvilinear forms into her developed rhomboid structures, to more easily facilitate the looping arc-like movements of the colour organisation. The renewed preoccupation with curves, and her interest in deep but not illusionistic pictorial space, lead to a large temporary wall drawing carried out for the *White Noise* exhibition at the Kunsthalle Bern in May 1997. The sensation of layered planes, previously achieved through complex colour relationships, is here the result of simple black and white drawing. The wall drawing has a major effect on her colour work. First results of this development are included in the exhibition *Bridget Riley: Works 1961–1998* shown at the Abbot Hall Art Gallery, Kendal (Cumbria), in the winter of 1998–9.

1999–2000

In the 1999 New Year's Honours, Riley is appointed Companion of Honour. In June the exhibition *Bridget Riley: Paintings from the 1960s and 70s* opens at the Serpentine Gallery, London; on this occasion a collection of her writings and interviews, *The Eye's Mind: Bridget Riley. Collected Writings 1965–1999*, is published. In October the exhibition *Ausgewählte Bilder / Selected Paintings 1961–1999* is shown in the Kunstverein in Düsseldorf. It makes a connection between the early black and white painting *Kiss* (1961) and *Rêve* (1999), the first fully achieved painting using the new curvilinear rhythm. In spring 2000 her biggest architectural commission to date is completed: a hanging, curtain-like installation in the atrium of Citibank's European headquarters in London designed by Norman Foster and Partners. Extending over eighteen floors it consists of three planes of coloured aluminium plates suspended by steel cables. Although related to her rhomboid paintings, this open construction changes according to the viewpoint from which it is seen and the conditions of light in the office tower. In the summer a group of her new curve paintings and related works on paper is shown in London for the first time at Waddington Galleries, an exhibition organised by Karsten Schubert. In the autumn the Dia Center for the Arts in New York mounts a survey of her work under the title *Bridget Riley: Reconnaissance*. The exhibition is complemented by a show of recent paintings at PaceWildenstein. Both shows mark a major re-evaluation of her work in the USA. At the end of November she takes part in the international symposium *Das Bild: Image, Picture, Painting* at the Berlin Academy of Arts.

2001–2

Riley focuses on preparing a Paul Klee exhibition for the Hayward Gallery in London (co-curated with Kudielka). She participates in the Santa Fe Biennial, *Beau Monde: Toward a Redeemed Cosmopolitanism* curated by Dave Hickey, with the painting *Evoë 1* (2000). The exhibition *Paul Klee: The Nature of Creation* is shown at the Hayward Gallery in the spring of 2002. In March, *Bridget Riley: New Work* opens at the Museum Haus Esters and the Kaiser Wilhelm Museum, Krefeld, the first museum show dedicated exclusively to the new curvilinear paintings. On this occasion an extended German version of *The Eye's Mind: Bridget Riley* is published under the title *Malen um zu sehen*.

2003

The year is dominated by the preparation and installation of Riley's retrospective exhibition at Tate Britain, London, which opens in June. Together with curator Paul Moorhouse she selects fifty-six paintings from all periods since 1961 along with a group of preparatory studies that give an insight into her working methods. For the exhibition she makes the wall drawing *Composition with Circles 3*, which links the early black and white work with her most recent paintings. The show is received to universal critical acclaim and draws 98,000 visitors. In September, Riley is awarded the Praemium Imperiale for her lifetime's achievement as a painter. She travels to Tokyo for the official award ceremony and delivers a message of thanks on behalf of the other laureates (Mario Merz, Ken Loach, Claudio Abbado and Rem Koolhaas). During this trip she revisits some of the masterpieces of ancient Japanese art in Tokyo and Kyoto.

2004–5

A new retrospective exhibition travels to Australia and New Zealand. It is shown first at the Museum of Contemporary Art in Sydney and later at the City Gallery Wellington. In modified form the show is later presented at the Aargauer Kunsthaus in Aarau, Switzerland. A small survey is shown at the Cranbrook Art Museum in Bloomfield Hills, Michigan. Riley continues to develop her work steadily in the studio. Among the new works exhibited in autumn 2004 at PaceWildenstein in New York is *Painting with Two Verticals* where for the first time the dynamism of the curves is both countered and enhanced by vertical divisions. She becomes a member of the Academy of Arts in Berlin for which she makes another

wall drawing, *Composition with Circles 5*. Her work continues to be included in the growing number of historical surveys covering the optical and kinetic tendencies in twentieth-century art. The environment *Continuum* (1963), which was part of her second solo exhibition at Gallery One, London, is reconstructed for the exhibition *L'Œil moteur: Art optique et cinétique 1951–1975* at the Musée d'Art moderne et contemporain, Strasbourg. In April 2005 she delivers the Seamus Heaney Lecture at the University of Dublin on the subject of 'Working'.

2006–7
2006 is characterised by intense work in the studio, which by the autumn leads to an unexpected new departure. Riley discovers that her preparatory work with cut-out papers allows her to open up the rectangular picture format, thereby making the white wall an integral part of the field. She explores the potential of this discovery in several studies and finally in *Wall Drawing 1* which is first shown at Galerie Max Hetzler in Berlin and subsequently at PaceWildenstein, New York – a double show of new works in both the gallery's uptown and downtown branches. At the same time, the Museum of Modern Art presents the exhibition *Georges Seurat: The Drawings*. Riley contributes a catalogue essay, 'Seurat as Mentor', in which she acknowledges her debt to the work of the French artist. The coincidence of the MoMA and PaceWildenstein exhibitions makes the critic of *The New York Times* express doubt at the conventional assessment of Riley's work in current art history: 'More and more, however, Ms. Riley comes across less as an Op artist than as the last living Post-Impressionist.'

2008
The largest ever Riley retrospective exhibition opens at the Musée d'Art moderne de la Ville de Paris in June. Fabrice Hergott, the director of the museum, calls it a 'historic event' not only because it is the first comprehensive show of Riley's work in France but, more importantly, because it is a homage to the historical roots of her art. Selected by Anne Montfort in collaboration with the artist, the exhibition consists of fifty-six paintings and about eighty drawings covering her development from the early pointillist work in the 'method' of Seurat to the most recent curve paintings. For the long curved room of the museum Riley creates *Composition with Circles 6*, by far the largest work of this kind. Also included in

the exhibition is *Wall Painting 1*. Apart from a substantial catalogue, the exhibition is accompanied by a French translation of her collected writings, *L'Esprit de l'œil: Bridget Riley*.

2009
In the winter of 2008–9 Karsten Schubert shows *Circles, Colour, Structure: Studies 1971*, a previously unexhibited group of studies executed in 1970–1. The show subsequently travels to Galerie Max Hetzler in Berlin. The critics are amazed by the freshness and vitality of the work: 'Bridget Riley is undoubtedly a classic whose early power of creation continues to the present day.' In July, Riley receives the Award of Companionship of De Montfort University, Leicester. *Flashback*, a UK touring exhibition of Riley paintings and studies from the Arts Council Collection opens at the Walker Art Gallery, Liverpool, in September. During October, Riley is awarded The Kaiserring of the town of Goslar. First given to Henry Moore in 1975, it is Germany's most prestigious international art prize. It is accompanied by a retrospective exhibition at the Mönchehaus Museum (2009–10). The year ends with an exhibition of new paintings and wall paintings held in conjunction with Karsten Schubert at Timothy Taylor in London.

2010
Flashback continues, travelling to Birmingham Museum and Art Gallery, Norwich Castle Museum and Art Gallery, and Southampton City Art Gallery. Riley's interest in the fundamental role of drawing, revived by her essay 'Seurat as Mentor' (2007), leads to two events. In May a display of her portrait drawings from the mid-1950s is installed at the National Portrait Gallery, which will continue into 2011. It generates considerable interest across a wide public and is accompanied by a catalogue titled *From Life*, with autobiographical recollections by the artist and an essay by Paul Moorhouse. Riley's belief in the formative importance of such experience is revealed in 'Learning to Look', a talk that she gives at the British Museum in May as part of the evening lecture programme supporting the exhibition *Italian Renaissance Drawings*. The exhibition *Bridget Riley: Paintings and Related Work* opens in the Sunley Room at the National Gallery, London. It includes both a wall drawing and wall painting, as well as studies and easel paintings. The exhibition will run from November until May 2011.

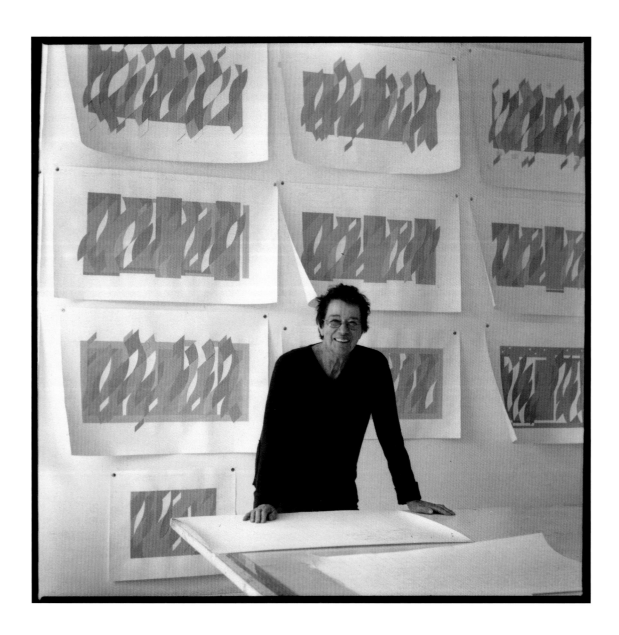

Fig. 28 Bridget Riley in her west London studio, 2010

Select Bibliography

Maurice de Sausmarez, *Bridget Riley*, Greenwich CT 1970

Andrew Forge, 'On Looking at Paintings by Bridget Riley', *Art International*, vol. 15, no. 3 (1971), p. 19

The Artist's Eye: Bridget Riley, exh. cat., National Gallery, London 1989

Bridget Riley: Dialogues on Art, ed. Robert Kudielka, London 1995

The Eye's Mind: Bridget Riley. Collected Writings 1965–2009, ed. Robert Kudielka, London 1999 (revised edn 2009)

Bridget Riley: New Work, ed. Martin Hentschel, exh. cat., Museum Haus Esters and Kaiser Wilhelm Museum, Krefeld 2002

Bridget Riley, ed. Paul Moorhouse, exh. cat., Tate, London 2003

Bridget Riley, 'Seurat as Mentor' in Jodi Hauptman, *Georges Seurat: The Drawings*, exh. cat., Museum of Modern Art, New York 2007

Jonathan Crary, Nadia Chalbi and Robert Kudielka, *Bridget Riley: Retrospective*, exh. cat., Musée d'Art moderne de la Ville de Paris, Paris 2008

Bridget Riley and Paul Moorhouse, *Bridget Riley: From Life*, exh. cat., National Portrait Gallery, London 2010

List of Works

Arcadia 1 (Wall Painting 1), 2007
Graphite and acrylic on wall,
266.5 × 498.5 cm
Private collection
(plate 8)

Red with Red 1, 2007
Oil on linen, 177.5 × 255 cm
Private collection
(plate 7)

Blue (La Réserve), 2010
Oil on linen, 183 × 381 cm
Private collection
(plate 10)

Composition with Circles 7, 2010
National Gallery, London
Graphite, acrylic paint and permanent
marker on plaster wall, 492.5 × 1,379 cm
(diameter of circle 98.5 cm)
Private collection
(mock-up, work in progress, plate 9)

A selection from the following studies
is included in the exhibition

Study for Blaze, 1962
Gouache on paper, 40 × 40.4 cm
Private collection
(plate 15)

Scale study for 'Shift', 1963
Gouache on paper, 36.7 × 61.6 cm
Private collection
(plate 16)

Study for Fragments Print 3, 1965
Gouache and pencil on paper,
50.8 × 36.2 cm
Private collection
(plate 17)

Untitled (Right Angle Curve), 1966
Gouache on graph, 58.8 × 55.9 cm
Private collection
(plate 18)

October 22nd Bassacs, 2008
Gouache on paper, 61.5 × 94.5 cm
Private collection
(plate 11)

Study B. 22nd April Bassacs, 2008
Gouache on paper, 61.6 × 93.3 cm
Private collection
(plate 12)

Jan 7th Cornwall, 2009
Gouache on paper, 61.5 × 95.5 cm
Private collection
(plate 13)

Revision 10th November, 2009
Gouache on paper, 58.3 × 92.7 cm
Private collection
(plate 14)

This exhibition has been made possible
with the assistance of the Government
Indemnity Scheme which is provided
by DCMS and administered by MLA.

Fig. 29 Bridget Riley in front of cartoon for **Exposure**, 1966

This book was published to accompany the exhibition

Bridget Riley
Paintings and Related Work

at the National Gallery, London, 24 November 2010 – 22 May 2011

Sponsored by **Bloomberg**

First published in Great Britain in 2010 by
National Gallery Company Limited
St Vincent House, 30 Orange Street, London WC2H 7HH
www.nationalgallery.org.uk

ISBN 978 1 85709 497 8
1018443

British Library Cataloguing-in-Publication Data.
A catalogue record is available from the British Library.
Library of Congress Control Number: 2010927364

Publishing Director Louise Rice
Publishing Manager Sara Purdy
Project Editor Jan Green
Editor Lise Connellan
Picture Researcher Maria Ranauro
Production Jane Hyne and Penny Le Tissier
Designed by Tim Harvey
Printed in the United Kingdom by St Ives Westerham Press

Front cover: Bridget Riley, **Arcadia 1 (Wall Painting 1)**, 2007
Back cover: Raphael (1483–1520), **Saint Catherine of Alexandria**, about 1507
Pages 2–3: Bridget Riley in her east London studio, 1989
Page 4: Bridget Riley at Gallery One, London, 1963

Unless otherwise stated, all works are by Bridget Riley
All measurements give height before width

Acknowledgements

Thanks are due to the following: Lise Connellan, Doro Globus, Jan Green,
Tim Harvey, Jane Hyne, Penny Le Tissier, Maria Ranauro, Karsten Schubert,
Amanda Sim, Andrew Smith and Claire Young.

We are indebted to the following for help with the execution of works *in situ*:
Hamilton Darroch, Sofia Jonsson, Miklos Kemecsi, Maria Timperi, Paul Le Grand,
Dominik Stauch, Wilfried Von Gunten and Anne Gabrille Von Gunten.